# PAINTING
## *the beauty of*
# FLOWERS
### WITH OILS

PAT MORAN

NORTH LIGHT BOOKS

CINCINNATI, OHIO

**Painting the Beauty of Flowers with Oils**. Copyright © 1991 by Patricia Moran. Printed and bound in Hong Kong. All rights reserved. No part of this book may be reproduced in any form or by any electronic or mechanical means including information storage and retrieval systems without permission in writing from the publisher, except by a reviewer, who may quote brief passages in a review. Published by North Light Books, an imprint of F&W Publications, Inc., 1507 Dana Avenue, Cincinnati, Ohio, 45207. First edition.

95  94  93  92  91     5  4  3  2  1

**Library of Congress Cataloging in Publication Data**

Moran, Patricia
      Painting the beauty of flowers with oils / by Patricia Moran.
           p.      cm.
      ISBN 0-89134-382-2
      1. Flowers in art.     2. Painting—Technique.     I. Title.
ND1400.M67      1991
751.45'434—dc20

91-6437
CIP

Edited by Rachel Wolf
Designed by Cathleen Norz and Sandy Conopeotis

# Preface

Painting flowers has been a passion of mine for quite some time. As I thought about what I could write that would really help those of you out there who share that passion, I thought about the many fine easy-to-remember "catchphrases" that have been used as keys to painting. My students keep asking me to put together a list of the ones I use—including my own—so they can use it as a permanent guide.

This book is, in part, my response to those eager students. I have tried first of all to express my love for flowers and painting. I explain the time-honored traditional method that I use to paint flowers exactly as the eye sees them—which is the method I call fine art. Throughout the book I have highlighted the key phrases I use to help keep myself and my students on track and have ended the book with a special list of these phrases. These apply to beginners and advanced painters, and perhaps some teachers will find them handy for times when they can't find the right words to explain a point. I hope this will satisfy my students and also be very helpful to you, my reader.

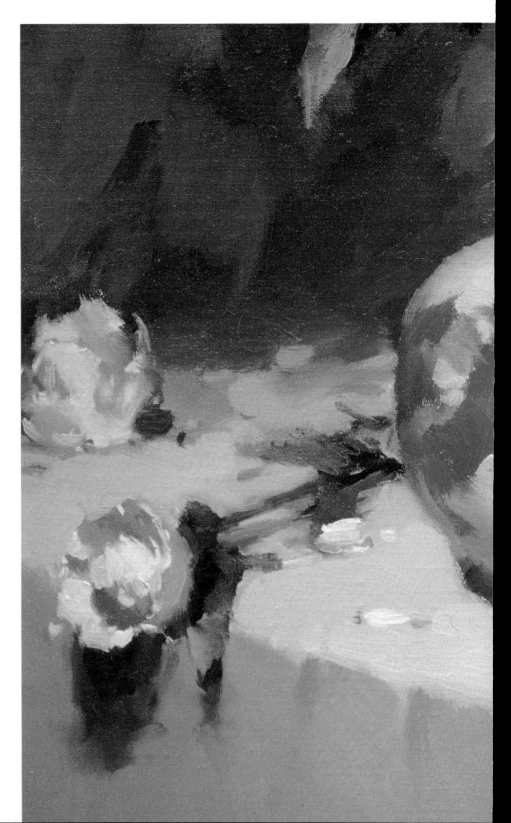

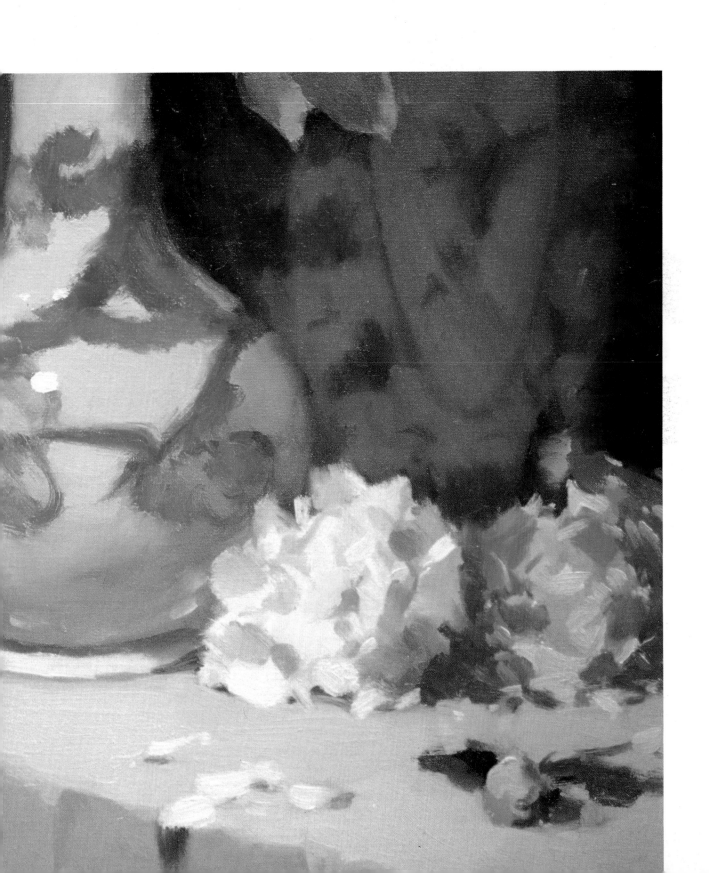

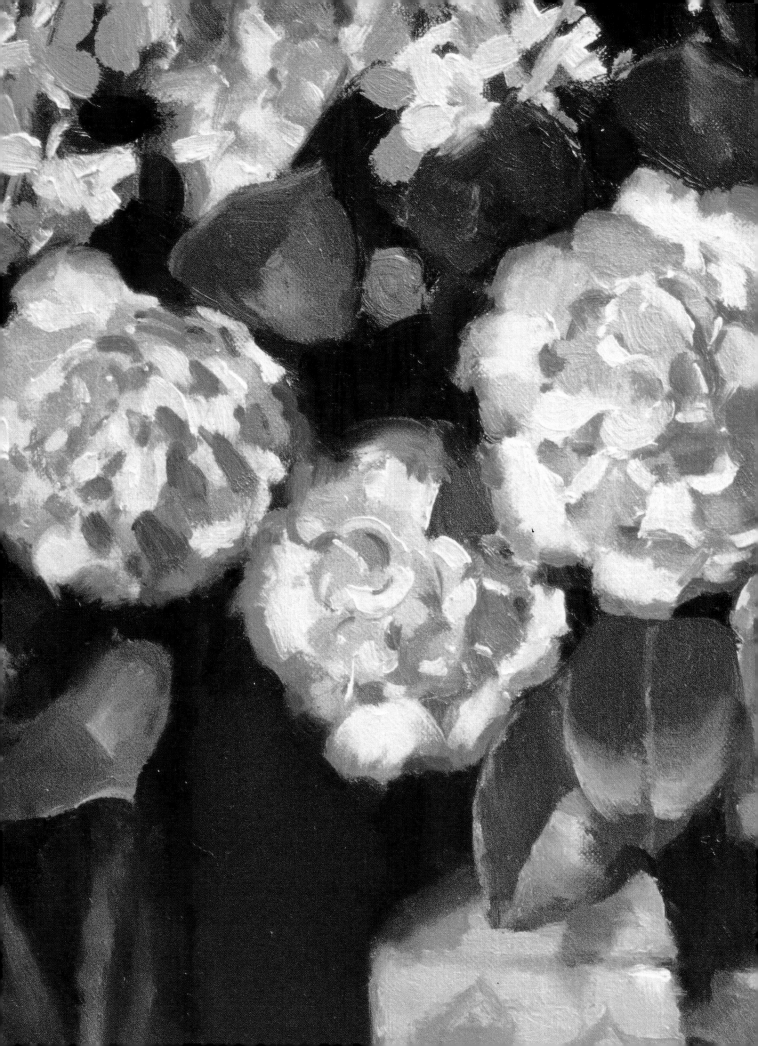

# Contents

# Introduction

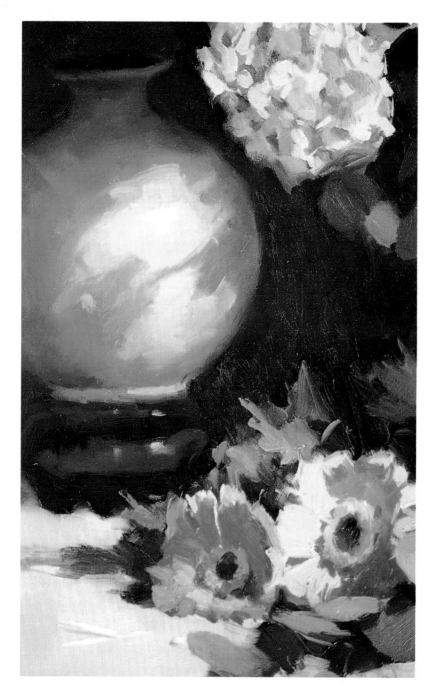

This is a practical, hands-on textbook for the flower painter. Basically, I try to show how to paint the beauty of flowers tonally. My intention is to guide the artist, in a simple manner, through the maze of artistic confusion.

When I buy an art book, I look at the pictures first. If the text is very interesting, I will read it. Usually it's over wordy so I don't bother. Therefore, I have tried to keep my explanations to a minimum, often reducing many paragraphs to a simple underlined phrase. This book opens with the beginning steps of a painting and takes you through to the signature. Five of "the most asked" questions are answered at the end.

So now let me begin—at the beginning.

## Early Influences

I wasn't one of those people who just *knew* they were going to be an artist. I knew I loved paintings and that's about all. (But I did win a thimble for the best drawing at junior school.) I also played the piano by ear. I got pleasure out of "fiddling" with my childhood paints, and I could play music without enduring hours of scales, so I never bothered with the formal torture of lessons. I was never too keen on being told anything. My father said "Be told!" all the time and I hated it. So I avoided formal learning and spent years just fiddling—with multicolored pen sets and fashion sketches.

My path to becoming a professional artist was a winding one. When I was a junior secretary, I remember seeing a print of Fragonard's "The

Swing" in the window of a décor shop. The color, opulence, and refinement of the eighteenth century cast a spell on me that sent me on a merry chase of self-education from which I have never recovered. In those days, the only place in my part of Australia that sold art books was Collins Book Cellar. It was dark and scary and the books were "gloom and doom." All the prints were of gory scenes and terror-stricken animals. The book I wanted had to be specially ordered and it took three months to arrive by sea. It cost one third more than my weekly salary and still, it didn't have a copy of "The Swing" in it. It was fifteen years before I actually got a print of that painting.

When I was twenty-eight, it occurred to me that I should stop being so absorbed in my now massive collection of art books and five tubes of oil paint, and get some formal training. After all, it worked with skiing. It wasn't until after having formal skiing lessons that I stopped falling over and had enough energy at the end of the day to go to dinner instead of bed. So began a five-year art teacher search. It was all trial and error. Uninformed teaching was the biggest barrier, but each time I got a little closer to quality.

In 1976 my mother and I went to America for my cousin's wedding, and I took the opportunity to see every art gallery in the States, coast to coast. It was the Washington Art Gallery that did it. It was like seeing "The Swing" all over again, only worse. I knew what I wanted to do. At the age of thirty-two I quit my job to learn painting. And as fate would have it, when I got home I finally found the teachers I wanted.

The next five years were a merry-go-round of learning, working for exhibitions, temporary secretarial assignments—probably the worst and happiest time of my life.

In 1982 I won the Alice Bale Overseas Study Scholarship, and in May, 1985 I was asked by the Victorian Artists Society if I would give a six-week workshop, which somehow just kept going.

## On Teaching

Teaching is a part of my busy routine as a practicing artist, and it is an art form in itself. Being a teacher while still learning myself helps my students understand the way I cope (or don't cope) with things that are new to me, as they will have to learn to handle things that are new to them.

The advantage of the direct tonal method that I use is that something happens immediately—you paint first, draw later. By establishing masses rather than drawing, the artist can quickly establish the character and natural attitude of a subject. Painting this way makes you feel that something is happening, and that feeling maintains interest. And enthusiasm often makes up for any lack of talent.

I was a secretary and personal assistant before I threw it all in to learn painting. During that time I trained many secretaries and receptionists. I found that being direct, clear and repetitive produced the best results, and I have tried to use the same principles in teaching painting.

In my class I was explaining for the twenty-thousandth time a certain key to solving a problem to a new student. As I progressed around the class I complimented one of my older students on an area of her painting. She said, "I heard what you said to the other student, and after all this time it suddenly made sense." She had reached a stage in her progress when it clicked. So I continue to be repetitive. *Someone* will understand, though it may not be the person I am addressing.

For this reason I developed the list of catchphrases I mentioned. Some came from my teachers, some were made up, but these phrases give me a framework to work within. They can sometimes help us get through the "maze" when the going gets tough. But what always revives my enthusiasm is simply the unfading beauty of flowers.

P. Moran

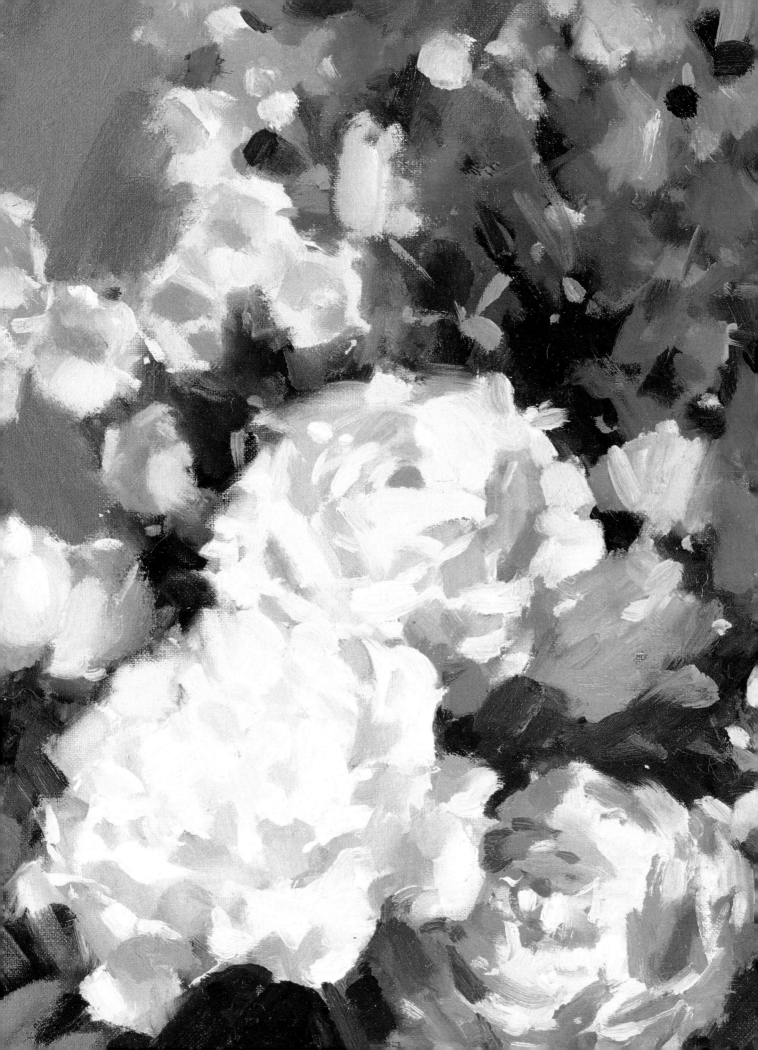

# PART I

# First Things

# *Using your equipment efficiently*

I try to devise as many energy and time-saving routines as I can. It may mean the difference between a good painting and kindling for the fire. Let me explain.

When I worked as a temporary secretary, for each temporary job I did, I had to use a street directory to get there—which, of course, didn't indicate the number of traffic lights or whether a street had "go-slow-bumps"—find the office, then a parking spot, learn a new typewriter and switchboard, and memorize a new set of names and faces. I was exhausted at the end of the day. The most time-consuming job was matching the names to the faces. I couldn't tell you how often an unknown face would sail past the reception desk while I was on the phone and say, "I'm going out for an hour." Worse still, he or she would probably add, "So would you cancel that other appointment?" I spent a lot of time trying to describe the normal-looking mystery person to a dozen others and then trying to find out which appointment to cancel.

The longer term job was great—I just got in my car and daydreamed while the car seemed to drive itself to its usual place. People I recognized gave messages I understood; I had energy at the end of the day and then a good night's sleep.

Painting is a permanent recording of something temporary. A painting may last five hundred years. Yet, a few moments may be the only chance you have to paint the last living bald eagle, Auntie Mary's prize-winning edible sculpture, or the sunshine in Ireland. You may not have time to remix puddles of paint, find the dark brush, or chase your most-used color from behind your elbow. Or, if you are like me, you may not have the energy. I was behind the barn door when they gave out stamina. I can work around that fact in normal life, but not in painting. I could muddle through a typing assignment with the correction tape, put on another layer of mascara for the cocktail party, or thaw a frozen pie for dinner—but I can't trick the canvas. Tiredness results in bad measurement, incorrect tones, and a worn-out looking painting. The flowers are fresh; it is the artist who is drooping.

It is important to develop a painting routine to save time and energy. The more time you save the more energy you will have. *A painting is only as good as its worst point.* Those last brushstrokes when you are at your wit's end can either make or break a painting.

It is important to develop a painting routine to save time and energy. The more time you save the more energy you will have.

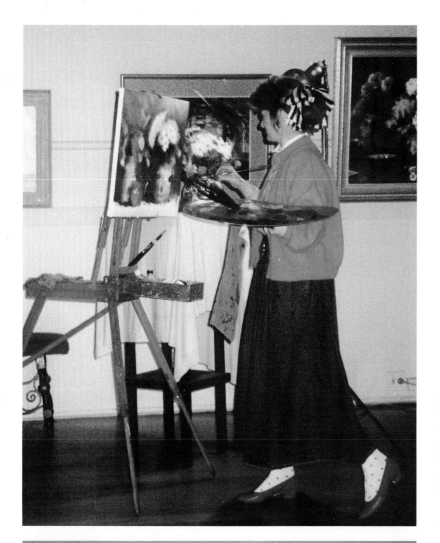

It is always important to have an efficient way of setting up your painting equipment. But when I'm up in front of people doing a painting demonstration as you see here, I can't keep everybody waiting while I search for a color or for the right brush. Having a routine saves time and energy (and in this case saves holding up the show, too).

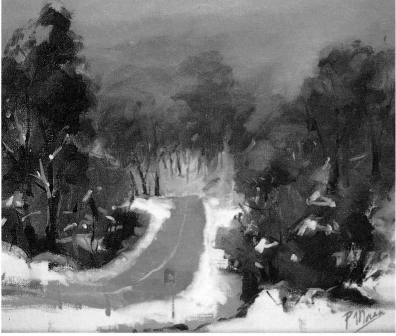

**Road to the Snow**

*10" × 8" (25 × 20 cm)*
*Here is another situation where an efficient routine is a must. When I'm out painting landscapes, especially beautiful snow scenes like this one, I don't want to waste time that I don't have. The light changes, and the hands freeze, all too quickly.*

## Paints

I only use Winsor & Newton artists paints. I am used to their consistency, their colors and their texture. The palette is set out from light to dark, with white nearest to the cup of medium, as white is the color most used. If I mix my tones following the order I set out my paints, I will have light on one end and dark on the other. This enables me to reach unconsciously for the color I want. You don't want to be searching for your colors; you need that time for bigger things.

These are the colors I use. They are listed in the order that they appear on the palette.

Flake or Titanium White
Cadmium Lemon
Cadmium Yellow
Yellow Ochre
Cadmium Red or Vermilion
Indian Red
Raw Umber

Alizarin Crimson
Ivory Black
French Ultramarine
Viridian
Cadmium Orange*
Cerulean Blue*
Cobalt Blue*

*These are only added if the particular subject needs it. Don't forget: red, yellow and blue make everything.*

## Palette

I have a palette that was designed by a teacher so that when the paints and brushes were added, the weight was distributed evenly. Also, it was made out of $\frac{3}{16}$-inch fine plywood, which cut the weight down considerably. The end is closed around the brushes so that the brushes are supported, and when the palette is put down, the brushes will sit there as you left them. Periodically I take my original palette down to the lumberyard and ask them to make me as many as they can out of one large sheet of the fine three-ply. They don't usually put the holes in the middle. They are so busy cutting up barge poles that my palettes are the last thing they want to fiddle with. You can cut the holes yourself with a utility knife and smooth the edges with a curved file.

You don't have to paint them white as some people do—just start using them. It's better to work on a neutral-toned palette, as it is easier to judge the tones you are mixing. A white palette makes it extremely difficult to see the subtleties. Before long the oil and paint will have sealed the wood with a lovely neutral shiny finish. Perfect. If you don't want to start from scratch—the new wood does soak up quite a lot of oil from your paints—just wipe it over with the left-over oil and paint from your present palette every time you clean up. The new palette will soon be ready for use.

*This palette is set out for a right-handed person. The most used color is the white, which is set next to the paint dipper—saving time and motion. The three starred colors are colors I don't normally use. I sometimes find cadmium orange useful for flowers or clothing in portraits, and it also makes nice greens in landscapes. Cerulean blue and cobalt blue I seem to add only when doing landscapes. I used to use them a lot, but find I can usually get along quite well without them. The fewer paints you set out the better. Learn to Mix!*

CAD. ORANGE

CERULEAN BLUE

COBALT BLUE

## Brushes

**Use round brushes.** Round brushes are more flexible; they go around corners and edges well. One brush can go from a point to a broad stroke depending on the pressure used—which saves holding a lot of different sized brushes in the same color. But the saying goes: *Big brush, big area; small brush, small area.* Using all flat brushes can give a uniformity to your painting and can tend to give it a slick appearance if you are not careful. At first I painted with flat brushes, but when I began learning a more traditional method, I was persuaded to change over. It nearly killed me; I felt that I'd taken two steps back in my progress. However, it made all the difference in my work, and I took many steps forward thereafter. I threw out all my flat brushes except one small one and one broad, just in case I ever needed them going sideways up a tree or stalk, but I have never used them. They are now relics of my student days that I occasionally gaze fondly upon.

## Medium

I begin with pure turpentine in my dipper, which keeps the block-in moveable, and you can still rub it out weeks afterwards—although not as easily as when first painted. As I begin to make the permanent, executive decisions, I add stand oil, to the consistency that suits me.

Stand oil is so called because if you stood linseed oil until it reached its final stage it would become stand oil. They do, however, speed up the process for manufacture. Linseed oil is heated in a stainless steel vessel under controlled conditions (polymerized) and is taken to different stages of viscosity—until it becomes like honey. Both linseed oil and stand oil dry through oxidation, not evaporation. The advantage of using stand oil is that it never yellows and never cracks,

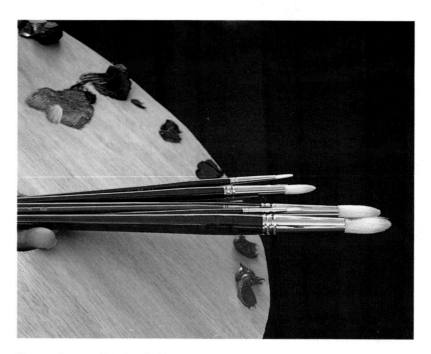

*Here are the round brushes that I use.*

although after a great deal of time it does darken somewhat. It's just the thing for keeping those paintings fresh and new. I have used oil painting medium quite happily, but stand oil seems to suit the way I work; it's just a personal thing.

## Retouching Varnish

Retouching varnish is used when a painting is done in stages. When the first stage is dry, and you are ready for another sitting or to continue with your still life or landscape, you cover the whole canvas with retouching varnish. This serves two purposes: one, it allows a smooth transition from the old work to the new; two, it restores the painting to the way you left it—wet. Wet tones and colors are different from dry ones; they are generally darker and richer. To mix and match those tones and colors perfectly, you will need to bring the old ones back to the way they were.

If you are painting straight through from start to finish, you won't

need retouching varnish until the painting is finished and dry; then you can apply a coat. This will remove the dry patches and give the painting an even finish. You will have to wait at least six months for it to dry thoroughly enough to use Damar varnish. In the meantime, retouching varnish will do the job. In fact, it can do the job permanently if you wish.

Gently apply the liquid with a soft brush; you don't want to lift anything off. I like to lay the canvas down. I seem to be able to see it better and there's less chance of a drop running over a face and drying there. Don't use the spray unless absolutely necessary. I don't believe it is as good as the liquid, and it is unsafe to use it in the studio around people. The only time I have used it was when I had four days to do a portrait of a girl who was on holiday. We had a sitting each day. The paint was too wet to brush on the retouching varnish and too dry to enable the new paint to blend in with the old. In that case, the spray-on varnish was very handy. I used the spray outdoors.

# *Painting what you see*

Oil paintings are often painted life size. As far as I can remember I have painted all my still life flowers life size, that is, the actual size that they are. Of course, if there are a lot of objects and flowers in the subject, they can't all be life sized if they are at different distances from the viewer, but the main flowers are done as closely as is reasonable to life size. Probably 90 per cent of my portraits also are done life size.

The reason for this is that it adds to the life-likeness of the subject, and as the oil medium lends itself to flowers and flesh (it is said that if you can paint flowers, you can paint people) why not use the medium to the fullest? If you can create in the viewer of your painting the feeling that he can smell the roses or touch the person in it, then that is the nearest thing to having the subject to live forever. Also, as paintings, particularly large ones, tend to be hung too high on walls (they should be hung on eye level but mostly are not), anything smaller than life size tends to look dwarfed and to lose its impact.

If you choose not to paint life size, rather than going slightly down in size it is better to go quite a bit smaller, so that your painting is obviously not meant to be life sized; otherwise portrait subjects look a bit monkey-sized and flowers look like they were picked out of season. However, all situations are different and all tastes are different (thank goodness). Any size that works, works.

*Painting what you see means looking carefully at each object and not relying on previous knowledge. These two sunflowers reveal that no two flowers really look exactly alike. In fact they look very different. If I had painted them to look like my idea of a sunflower the painting would have been far less interesting.*

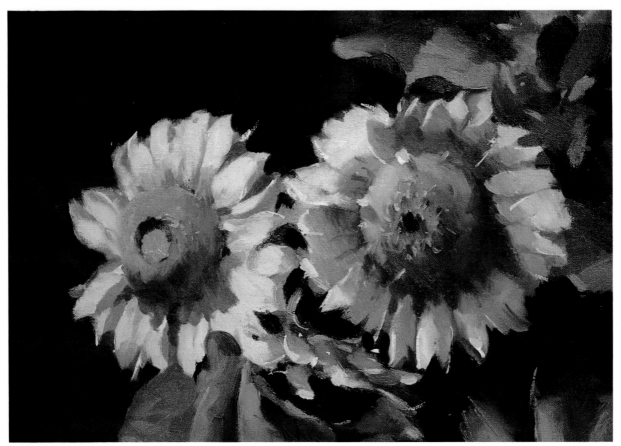

## Standpoint

In order to see what you are painting, and paint what you are seeing, you need to establish a standpoint to work from. Mark a spot ten to twelve paces back from your canvas so you can see the canvas and the subject equally. Make sure that you return to that spot for every evaluation. As there is *more look than put* in painting, you will be spending more time at your standpoint than at the canvas.

When you are at your canvas you only paint. You do not look or "peep" at the subject at all. You paint only what you have evaluated from your standpoint.

## The Viewer

Cut a rectangle of approximately 1 × 1½-inches (3 × 4 cm) out of a small piece of cardboard. Use this to select the exact area of the subject you are about to paint by simply holding it up and observing the subject through it. It eliminates the surrounding distracting areas, and you can see right from the start exactly the way you want the finished painting to be placed on the canvas. More sophisticated models with cross hairs are a great help, but a plain old empty slide case will do. I find it essential for judging how certain areas should be placed, and I note how far from the edge, center, bottom or top these areas are.

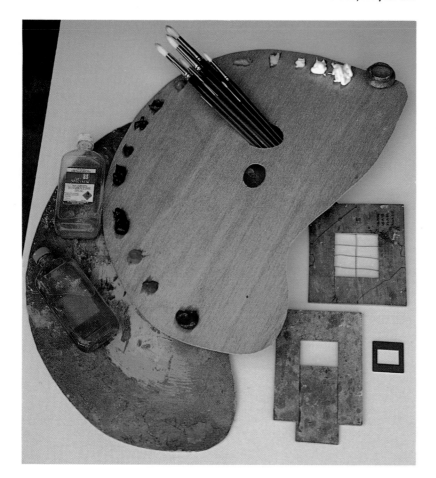

*This shows the palette with the brush section in use. I can put the palette down without all the brushes falling out. These are round brushes, ones that form a point. On the right are three viewers. The top one has cross hairs made of wire; the second is made of cardboard and has a sliding section that allows you to make the viewing hole exactly the shape of the canvas; the third is a photographer's transparency slide cover, which in most cases is all you need. Underneath is my original palette. It began like the new one on top, and the years of oil and paint made it this nice neutral color. The two bottles are turpentine and stand oil (see text for explanation).*

## Sight Size and Life Size

Sight size is painting your canvas the same size that your subject appears. If your canvas is right next to your subject, you will paint it roughly actual size. Sight size would equal life size. If you move your canvas away from the subject and appropriately move your standpoint back, you still paint sight size—the subject will appear smaller and much more of the background will be included in the painting.

In my class at the dear old Victorian Artists Society—where the inconvenience is endearing only in hindsight—we have to squeeze in about twenty students with their equipment and observing space. There is no way for twenty students to place their canvases next to the subject, a portrait model. So instead of painting sight size, which would include the model and all the surroundings, they paint the head life size. The human head measures approximately nine inches long (23 cm), so what they have to do is measure and determine the ratio between sight size and life size. So, once you have decided on the scale you are going to use, how do you measure to get an accurate representation of your subject? Follow me.

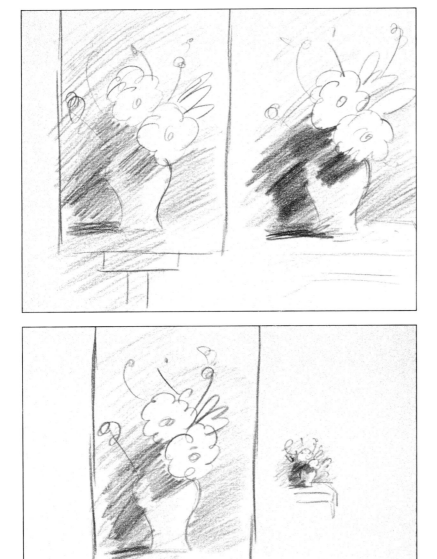

*If the canvas is right beside the subject it is easy to paint life size, because life size will equal sight size. Standing back ten paces you can observe both the painting and subject together.*

*The farther you move your canvas away from the subject, the smaller the sight size will be. If you only painted sight size you would sometimes have to include much more of the background than you may desire. So, in order to paint life size in this situation, you use measurement.*

## How to Measure

There are two main types of measuring, the direction and relationship measurement, which I call directional measurement for short, and the how many times into measurement. For either type of measuring:

**1.** Select a thin brush without much shape. That swelling shape on the brush is designed to keep the brush heads separate while you are holding a lot together. If you use a large curved brush, it might throw your measure off.

**2.** Don't point the brush at your subject (see diagram).

**3.** The more you measure, the more you won't have to measure. The more you keep altering it to get it right, the more your eye will become attuned to it being right, and eventually you will get it right the first time. Think how much time that will save.

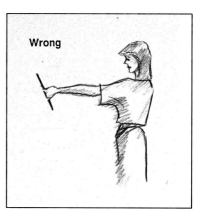

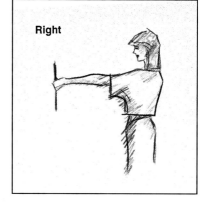

*"Don't point; it's bad manners." In this case it's bad measurements. I've seen people point their measuring brushes year after year without ever knowing they are doing it. When you are measuring something difficult, like a foreshortened book or a receding chair seat, stop and see if you are pointing the brush instead of holding it vertically (parallel to your body). You need to check often, because it is so easy to drift back into this bad habit.*

Don't forget DIRECTION, RELATIONSHIP and FORM. They are the three things to remember about measuring.

DIRECTION      the actual direction (as the crow flies) from one point to another

RELATIONSHIP      the relationship of ALL the points to each other

FORM      being aware of the formation or depth of the object — the third dimension

Measuring helps you to keep your objectivity, a most difficult thing to do. It is very easy to paint with inspired passion and lose all sense of proportion. Keep a cool head, keep measuring and try to be totally objective. By aiming to be correct and not aiming for a likeness, you will have a better chance of actually producing a likeness.

## Direction/Relationship Measurement

The approach in the following illustrations appears primitive, but it works. One measurement method I use a lot is to place the brush vertically on the side edge of a vase and see what falls on either side of it. I then see if my canvas matches up. Or, I place the brush through the middle horizontally and ask myself: "What is above it and what is below it?" It's amazing just how wrong you can be. Also, I measure the angle from the base of the vase to the farthest flower (or from the model's chin to the edge of the hat brim). Just keep going, and don't go into oil until you've done the best you can.

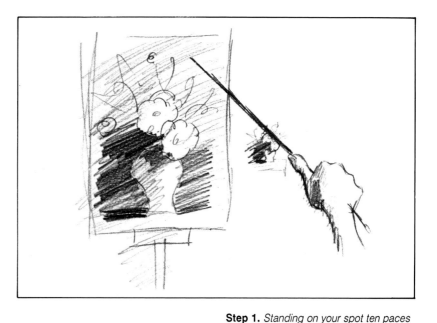

**Step 1.** *Standing on your spot ten paces back from the canvas, use the full length of the brush. Without pointing the brush, measure the exact direction from one point of your subject to another—not the length, the direction. For example, the farthermost point of one rose to the farthermost point of another.*

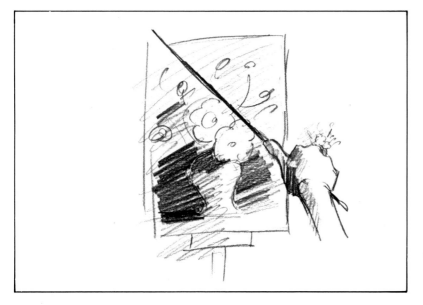

**Step 2.** *Now freeze! Hold your brush in that direction and walk right up to your canvas; lay that brush against the farthermost points of the same two roses. The angle between the two points should be exactly the same as the angle of the brush. If it isn't, fix it.*

**Step 3.** *Now go back to your standpoint and measure the direction and the relationship of every landmark, one to another, on that canvas. For example, use the leaf on the left as an anchor and fan out; then go cross country and see if these points relate to each other. If you correct one it usually throws all the others off, and it can be quite a nightmare—but keep at it. As I have said, the more you measure and correct the more you won't have to.*

A well-measured painting will have much more authority and drama than a carelessly placed one.

## How-Many-Times-Into Measurement

In the illustrations that follow I have used a vase of flowers to demonstrate this way of measuring, but it will work for any other subject. For example, how many times does the head go into the body, or how many times does the tree go into the hill, and so on. You can use it sideways, up and down, or any way you like — as long as you keep measuring.

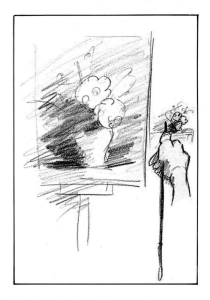

*To take sight size to life size on the canvas, use the "how-many-times-into" measurement.*

**Step 1.** *From your standpoint (ten paces back from the canvas) use the tip of the brush to get the exact length of the vase.*

**Step 2.** *Don't move from your standpoint and don't move your thumb on the brush. From your shoulder joint, move your arm up slightly so that the section of your brush that corresponded to the size of the vase is now in front of the flowers. You can then determine how many times that brush length goes into the floral section of the arrangement.*

**Step 3.** *Now that you have found how many times the vase goes into the flowers (in this case about one and one quarter), you leave your standpoint and go right up to your canvas. Lay your brush on the canvas and measure the length of the vase you are painting. Mark the vase's length on the brush with your thumb. (If it is a big vase, it could use the full length of the brush.)*

**Step 4.** *Without moving away from the canvas and without moving your thumb on the brush, move the brush up on your painting and see if the vase length goes the same number of times into the flowers' length. The ratio should be the same as your first measurement. If it isn't, fix it.*

## *This is the way I would go about measuring a subject like this. I would:*

**1.** Hold the brush vertically through the center of the vase and check that both sides are the same on my canvas as they are in the subject.

**2.** Measure from one point to another and get the exact angle from the top knob on the tureen to the edge of the main flower.

**3.** Hold the brush horizontally across the top of the glass jug and observe whether the lid of the tureen begins above or below it.

**4.** Hold the brush horizontal to the base of the tureen and observe whether:
    a. the handle of the glass jug begins above or below it;
    b. the dark pattern around the base of the big porcelain vase sits above it or below it.

**5.** Keep the brush horizontal and work down this complicated area, holding it across the water line of the jug and observing whether it sits above or below the dark pattern band at the base of the big vase.

**6.** Then go across the base of the main vase and observe what falls above it and below it—across the whole width of the canvas. It sounds like hard work, but the more you measure the more you won't have to, and you really couldn't have all these objects floating around the canvas. This is not kid stuff; we mean business here.

**7.** Measure the exact angle of the shadow.

**8.** (This is very important.) Measure the exact angle and relationship of the vase bases—one to another.

**9.** Hold your brush vertically to the edge of the vase. What shape is inside it and outside it? Measure *shapes* of dark and light areas.

**10.** Now get down to the little nuances to polish it off:
    a. Observe where the neck of the vase falls in relation to the base of the vase;
    b. Observe how much (or how little) the vase curves outside this vertical line. This one will keep you busy if you are trying to paint the inscrutable oriental vases. It is one of the challenges of my life to get them right.

Measure everything, get it as right as you can (without knocking the love light out of your eyes completely), and you will find the job gets easier with each new painting.

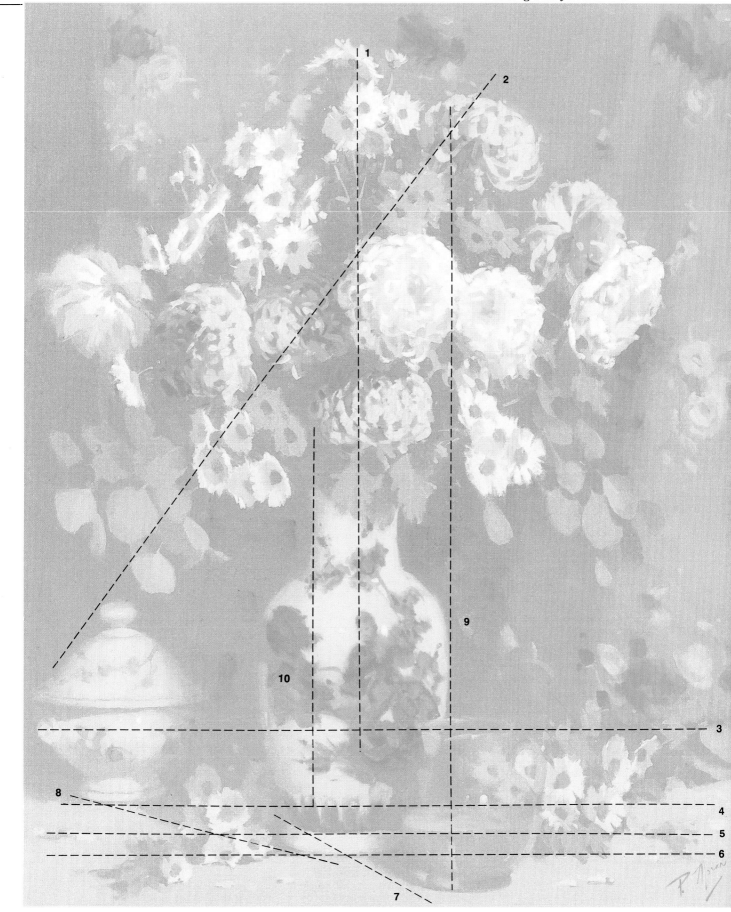

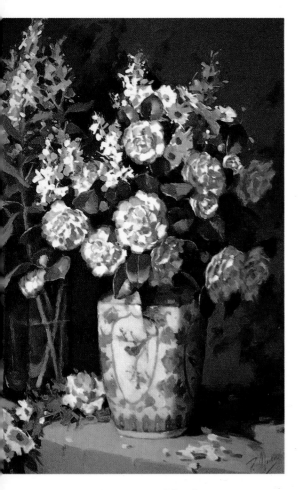

## Camellias and Stocks

*25" × 34" (63 × 86 cm)*
*Look at all the formations of objects that you have to be aware of in this painting. The stems in the glass vase have to go through the water line, a camellia, another leaf, and three color changes on the way up—and it still has to look like the same stem. The water line has to match the base of the vase, which has to relate to the table edge.*

# Consistency of Form

Accurate tonal values alone produce the appearance of the third dimension or depth, but inaccurate placement of these without follow up can undo the authority of the painting and destroy the truthfulness we are aiming for. You have to be aware of the roundedness of a vase, or an arm, and make sure things match up.

After the initial establishment of tonal areas without boundaries you then have to look for any awkwardness in the placement of those tonal areas. For example, if you have some long-stemmed flowers lying behind a vase, showing on both sides (but not in the middle), make sure they look connected. Don't have them appear two inches higher on one side of the vase than on the other. Or maybe a chair back showing on both sides of a model. Check that they match. You will have to imagine the bit you can't see. Just plotting tonal patches is not always enough; make sure those handles on the vase are even—don't have the viewer thinking that the potter must have been drinking at the wheel.

Measure until you are purple in the face and fall over from exhaustion. A well-measured painting will have much more authority and drama than a carelessly placed one. If you don't measure, you will automatically make the part that interests you look bigger. For example, most people make the eyes too big in a portrait, or the light side of a vase or face bigger than the dark side. Intermittent, objective measuring will help you avoid these mistakes.

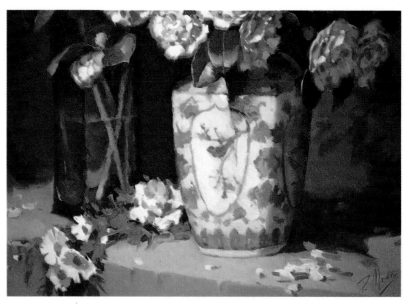

*Here the table edge has to go through the flowers that are lying down and come out the other side without looking awkward. The porcelain vase has to relate to the table edge and the other vase, and it has a design that also has to be observed very carefully.*

## Mixing Colors

I don't recommend mixing with a palette knife. If you do you are only making two jobs for yourself. The paint has to go through the brush, so you might as well mix with the brush right from the beginning.

Set out plenty of paint for the block-in. The block-in has to cover the whole canvas—no working in sections. I have watched some students set out these little pinheads of paint about one half inch apart up one end of the palette. Then they make these dinky puddles to cover a 24×30-inch canvas. It's like making a ball gown out of a bikini—it's not possible. Those small puddles will get used fast and the mixing job will have to be done again, and believe me, matching colors is much slower than mixing the first time. The colors never come out

the same way and the puddle gets bigger and bigger. We have all been in the situation where we have just about finished painting, and the viridian (or whatever) runs out. Then there's that mental war—can we make it without squeezing out that dob of paint that we will have to waste? Well, that will happen less if you are generous to begin with. *Stingy palette, skimpy painting*. After the block-in, when you get down to the slower, more detailed areas, you will use less paint, except probably for the background.

*If you are mixing a light tone, dip into the white first; if you are mixing a dark tone, dip into the darks first*. This helps keep the color nearer to the tonal range.

Do not dip into the medium first. Mix the paint first, *then* dip into the turpentine or stand oil. Every color has a different amount of oil and fluency. You may not need to add anything. If you go into the medium first, you are very likely to have a problem with paint you can't control.

Use one brush for each puddle of tone/color. Sounds excessive, but it works. You can't afford to slow down your thinking process and lose continuity by remixing anything. Remixing always takes longer than the first mix. Just reach for the brush that matches the area you are painting; that's quicker than remixing.

### Keeping the Palette Clean

Right; you've just run out of that lovely dark green that you mixed from black and cadmium yellow. You dip your brush into the black and then into the cad yellow. Oh . . . your cad yellow is now black, and you were just about to use it for a daisy center.

I try to make a routine of taking the dark colors from the back of the dob, around the palette edge, and the light colors from the front, on the mixing area side. The longer you can maintain this arrangement, the longer you can go before having to replace a spoiled color. It's all time and motion.

*When mixing my puddles I try to make a habit of going back to the laid out dobs of paint in a methodical way. If my brush is black, for example, and I need to dip into the cadmium yellow, I take the fresh paint from the back of the dob. I take the fresh paint from the front if my brush is a light tone. This helps to keep the paint cleaner for that much longer.*

# *Tonal painting*

A black-and-white photograph is a tonal picture. There is no color, just tone. If we all lived in the dark, we wouldn't know what anything looked like. Open the door a crack to let the light in, and the tiniest bit of light produces people, vases and furniture. So, accurate imitation of lights and darks produces the nearest imitation of what is in front of you. Tone is number one in producing a truthful representation of objects and atmosphere. The art term for this is chiaroscuro, which means putting a strong emphasis on the change from light to dark in a painting.

**My copy of *Vase of Flowers.*** *(Chardin. Original in National Gallery of Scotland.) A black-and-white picture is a tonal picture. This is my black-and-white copy of a Chardin painting. Regardless of what colors Chardin used, the counterchange of tone is paramount. He was fully aware of the relative value of light against dark and dark against light. He has painted a pattern of lights and darks.*

# Making Tonal Charts

Tonal values are relative. Nothing is light or dark unless compared with something else. Isn't the chart on the right amazing? Look how the middle tone changes. There's no trick, just mother nature. To make these charts for yourself: Rule two pieces of canvas into nine horizontal sections the width of a ruler (just over an inch).

**First Canvas.** Place the lightest light—white—at the top and the darkest dark—black—at the bottom. Half black and half white should make the middle tone. Middle tones are the hardest to get right. Then paint the third one down, and the seventh one down. Fill in the others. They should be so perfectly graded that when you half close your eyes there're no divisions, no jumping, just smooth grading. We call these "venetians" like the old blinds, because as one tone touches the next one down, it appears to lighten (tones are relative) and it resembles the blinds.

**Second Canvas.** Rule the canvas into the same nine sections, only rule a section vertically down the middle. Paint the sections the same as you did in the first canvas, except use your middle tone to paint the vertical section up the middle as well. This produces a remarkable illusion. The middle tone looks graded, appearing darker at the light end and lighter at the dark end.

That is why you have to paint your painting as a whole tonal unit. Painting in sections will produce a lack of unity, and certain areas will take on an isolated look—like a Cheshire cat without a body!

So while you mix your colors always be aware of the tone and the tonal range of the *whole* canvas. Think tone before color.

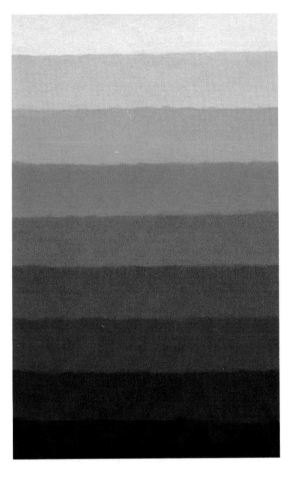

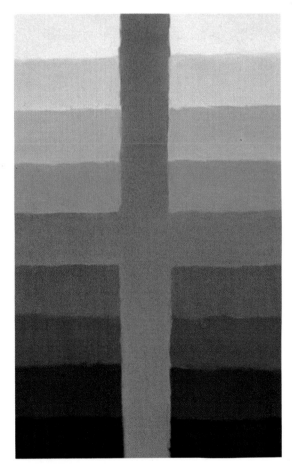

*If you squint your eyes at the chart on the left there should be a smooth transition from light to dark. The chart above never fails to fascinate me. It is the same as the one on the left, except the middle tone has been painted vertically as well as horizontally—the cross in the middle is one tone. It is hard to believe that it is not graded. It looks light against the dark and dark against the light because tonal values are relative.*

# Lost and Found Edges

Squint at your subject until most of the light is blocked out, and you will find that most of the edges will disappear. Only the obvious ones are left. Some edges will be "lost" and some will be "found." The reason that an edge becomes lost or obscured is either because it is surrounded by similar tones or because the eye is focusing on a hard or "found" edge. *The eye can only take in one thing at a time* (see "How Do I Finish a Painting?" on pages 122-123). So how do I control those hard and soft edges? By controlling the brushstrokes. Read on.

Hardness or softness of edge is one of four things to check on when comparing the subject to the canvas. It plays a major role in recording the subject truthfully. The four elements to check on are: tone, color, hard and soft edges, and proportion.

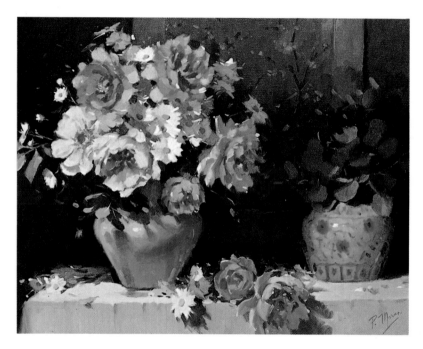

**Tree Peonies**

*36" × 30" (91 × 76 cm)*

*If you squint at this painting, the first hard edge you see is where the lightest light touches the darkest dark. It starts at the white peony against the dark background and goes down the edge of the pink peony next to it and then down the edge of the vase. It makes almost one continuous line that becomes the front of the subject. The eye tends to bypass the "lost" edges. The light side of the vase is the "found" edge; the other side is lost in a reduced tonal range and by a soft, broken edge.*

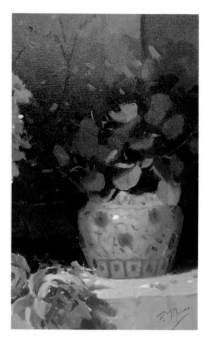

*The next most "found" edge goes from the highlight to where the leaf touches the vase. Both sides of this vase are "lost." The leaf area is in sharper focus but still of secondary interest to the main vase of peonies (see full painting). The edge of the print above the leaves is in focus, but the tonal range is reduced, so it does not stand out too much. The eye travels up that edge, around the print, and back to the peonies. Right! I have full control of where the eye goes in this painting by the counterchange of tone/color and lost and found edges. (See "placing the subject on the canvas," page 55.)*

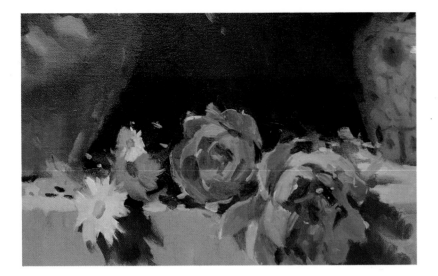

You can see how "lost" the vase edge looks next to the light side of the lilac peony where it touches the deep pink flower. The eye will then bypass the "lost" side of the peony—that is, the side with reduced tonal range, reduced color and softness of edge—and sail off to the next most "found" edge.

## Brushwork

### Painting Against the Form

What does this mean? Easy—instead of sailing down the curtain, across the horizon and up a gum tree, you go sideways up that curtain crease, up and down the horizon, or more accurately, you use brushstrokes in *every* direction over the whole canvas, regardless of the objects you are painting. The whole canvas is a complete unit. This encourages a more "painterly" appearance, keeps the edges soft until you are ready to bring them into focus, and maintains a continuity of brushwork so you don't get that "cut out and glued on" look. Not only that, you can stop in the middle of that long horizon, have a cup of coffee, come back and continue where you left off!

Right-handed people have a tendency to paint across the form from right to left. If there are too many brushstrokes going in one direction, it gives the appearance of the subject being painted in a rainstorm. Unless the brakes are put on at the edge of the painting with brushstrokes going some other way, the eye will sail out the canvas and never come back again. You must keep the eye in the

painting. Left-handed people do the same from left to right. Keep the brushstrokes going in all directions!

During my (approximately) second portrait lesson, I considered that I had painted the most wonderful background curtain. I had sailed down the creases with great accuracy, I had painted those straight lines so well I had, in fact, done a "curtain painting," and not a portrait at all. Those zipping, whizzing lines took all the attention, and the portrait was the last thing the eye rested on. Even worse than the clever painter is the one who *thinks* he's clever and paints those long lines with a shaky, unsure hand. The subject should be the first thing that attracts the eye, not the slickness or cleverness of your brushwork.

Another point to make about painting with the form is that there's a tendency to sail past where it should end. The strokes often go farther than intended, and unless the artist measures carefully afterwards, it can throw the drawing off. Also there's a hit-and-miss element: You might get it right once and never again. *Do not have any "happy accidents"* on the painting; you must be able to repeat everything that has been painted.

If there are too many brushstrokes going in one direction, it gives the appearance of the subject being painted in a rainstorm. Keep the brushstrokes going in all directions.

This is what is called "painting with the form." When accurate it looks slick and hard; when inaccurate it looks amateurish, unpainterly and—dare I say it—tacky. There is no control of lost and found edges and the eye doesn't know where to go. There are times when you *do* paint with the form, but not all the time.

When painting against the form the brush goes in all directions. Keep your painting as soft as you can, as neutral as you can, for as long as you can. *Notice the sideways working up the pink stripes. Now you have the soft groundwork to control where those final brushstrokes with the form will go.*

Which hard edge painted with the form does your eye go to? Probably all over the place.

Back in control again. There is only one hard or "found" edge here, the yacht, and when you look at it, those "lost" edges don't drag the eye away from the point of interest.

## Painting With the Form

There are areas on the painting that *should be* painted with the form. You are likely to find them more towards the end of the painting. In fact, there are some things that can only be painted with the form, but there are 90 percent fewer than most people think. For instance, there is a great temptation to paint daisies, petal for petal, with the form. That way they glare at you like white wagon wheels. However, if you squint at them and eliminate most of the edges you will see that they are made up of *very* subtle tones. Place these tones against the form, and there may be only a couple of petals painted with the form. Try and keep those brushstrokes with the form to a minimum, and you will be surprised what a difference it will make to your work.

**Wrong**. *These shasta daisies, which are all painted with the form, look stiff and plastic—and stare back at you as well! There's no way you can keep these clean.*

**Almost right**. *The brushstrokes are going against the form, but all one way. "Painting in a rainstorm," I call this, and a right-handed drift (mollydukes go the other way).*

**Right**. *Brushstrokes going in all directions. The only marks with the form are those tiny sable marks coming in towards the daisy centers. They are the only hard edges needed to bring that softness into focus.*

# PART II

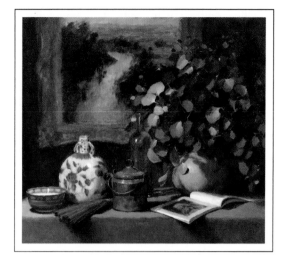

# On Flowers and Flower Painting

# Chapter four

# *About flowers*

I just happen to love flowers. Each season brings its own variety in regular rotation—camellias, sunflowers, iris—and as their turn comes around I am always surprised by how beautiful they are. When I've depleted my garden, then everyone else's garden, I head for the florist shops. They all know me; I'm sure they duck under the counter when they see me coming.

The fascinating thing is that seasons are never exactly the same, so the floral arrangements are never quite the same. One year, early shasta daisies will come out with late irises, and it may never happen again. Some seasons offer magnificent roses and poor daisies. You *always* have to keep your eyes open for peonies and magnolias—if you blink you miss them. One good rainstorm at the wrong time and there they go for another year. I haven't painted Japanese magnolias for five years now. Mind you, they are so much trouble that five years seems like yesterday.

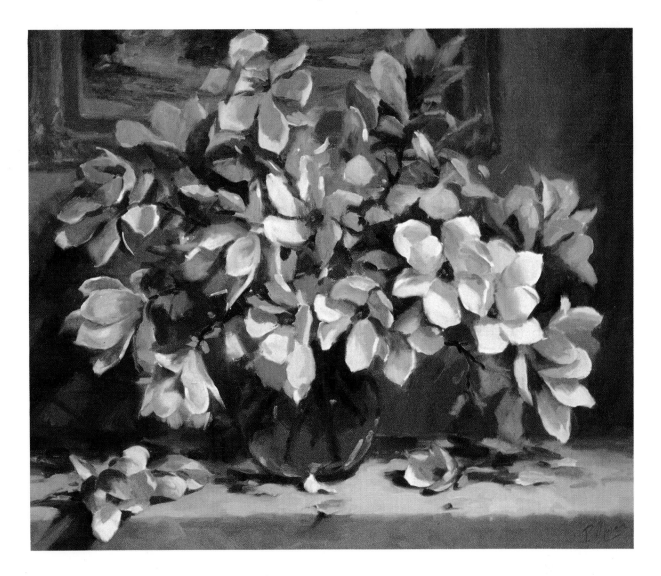

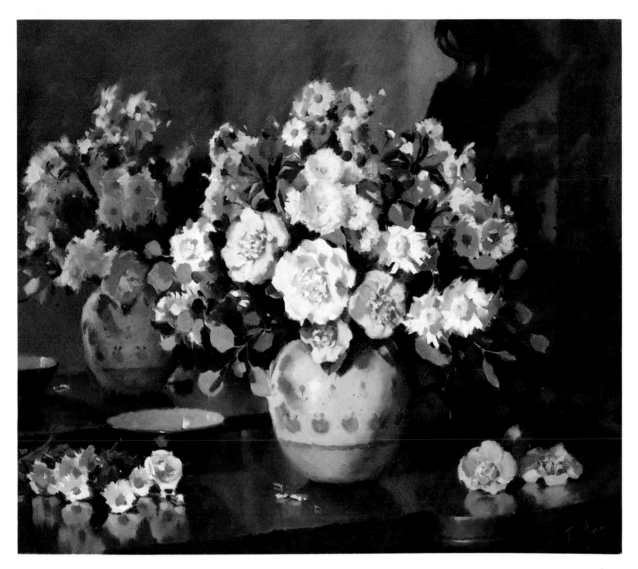

**Reflected Camellias**

*36″ × 30″ (91 × 76 cm)*
*Not only flowers, but double the flowers!*

◄ **Japanese Magnolias**

*36″ × 30″ (91 × 76 cm)*
*These were so much trouble I haven't painted any since. I did these five years ago.*

The great Australian impressionist artist Tom Roberts said, "Paint what you love, and love what you paint, and on that I have worked." It is not what you paint, but the way you paint it that counts.

I have to say, if I had to choose my favorite flower in the whole world, my choice would be the camellia. I grew up in a garden full of them; my father loves them too. Unfortunately for him, this passionate flower painter makes thrip and mealy bug seem like a happy alternative. I'm afraid his favorite trees are now a little on the bonsai side. The others are hopelessly misshapen—the flowers I want are always in the wrong place for good pruning. I get great exhiliration from painting camellias; they just seem to paint themselves. Do you ever get that odd feeling when you finish a good painting; you wonder who *really* painted it?

Something else that fascinates me is oriental blue and white porcelain. I'm attracted to it like a magnet.

Whenever I see some I go for it as if I've never seen any before in my life. The inscrutable oriental shapes beat me every time. They never come out the way they should. Who was the artist who said on his deathbed, "But I haven't got it right!" I think it was Monet. I have a pair of antique ginger jars that I have had for years and I still use them constantly—much to the chagrin of the gallery owners ("Not *that* vase again" or "We're going to have to buy you some new vases"). But I've *never* got them right; they beat me every time. To make matters worse, I have many that are very close in design, and everyone thinks they are all the same vase. I use them because everything just looks so right in them it seems a shame to use anything else. The great Australian impression-

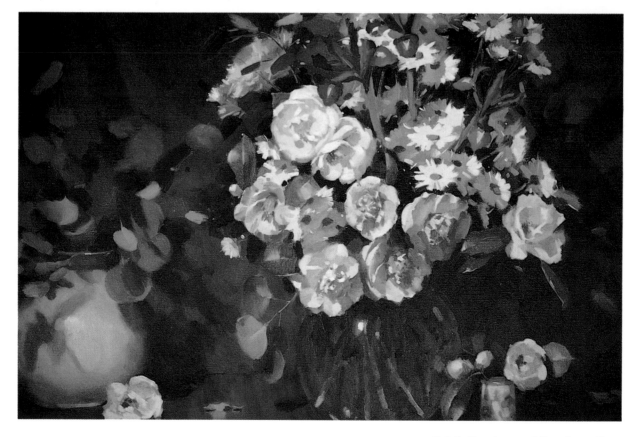

**Detail.** *From larger painting of camellias. I have to say that the camellia is my favorite flower. They look so elegant and subtle, but one good rainstorm and that's it for another year.*

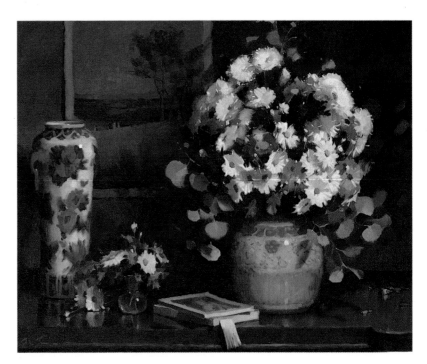

### The Blue and White Vase

*36″ × 30″ (91 × 76cm)*
*This is a still life with flowers. I call it "The Blue and White Vase" because the competition for attention was won by the long light hard edge of the strongly patterned vase. Even when the eye rests on the flowers, it is carried back to the tall vase via the horizontal line in the background print.*

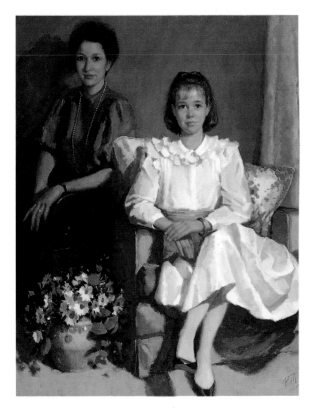

### Miss Sara Brookes and Her Mother

*36″ × 48″ (91 × 122 cm)*
*Flowers go anywhere. They don't have to be the center of attention.*

**Detail.** *Flowers with oriental blue and white porcelain vase.*

ist artist Tom Roberts said, *"Paint what you love, and love what you paint, and on that I have worked." It is not what you paint, but the way you paint it* that counts. The painting you can live with has been painted with tenderness. The others you can tire of before you leave the gallery. Flowers are as beautiful now as they ever were. A slick technique isn't going to say anything.

Ever wonder why the wonderful French painter Henri Fantin-Latour (1836-1904) did a lot of chrysanthemums and rhododendrons? I can tell you why: They stay alive a long time and don't move! They're great for Tender Loving Care. Those daisies that have siestas in the afternoon or water lilies that close up when the sun goes in are *trouble*. Poppies that do snappy little U-turns towards the light or the Australian native flowers that die the minute you finish the rub-in

are enough to test the most obsessive artist. It's worse than doing a portrait of a wriggling child.

When painting those changing flowers there's just one thing to do: MOVE! Paint as fast as you can paint—carefully. It's like a concert performance; everything you have learned—measuring, assessment and reassessment—has to all come together at one time. If you can do that and keep the tenderness you have it made. When my students complain that something is hard, I tell them, "That's why they give you a knighthood when you get it right. If it were that simple, it wouldn't be worth anything."

Flowers and still lifes were quite out of fashion when I began painting. For my second exhibition I was told that small landscapes would sell the best. Guess what went first? Still lifes and flowers. Why? Because I had painted what I loved with Tender Loving Care. Although I love painting landscapes, too, and times spent being out with friends of a like mind have been some of the happiest of my life; as I said before, I just happen to love flowers.

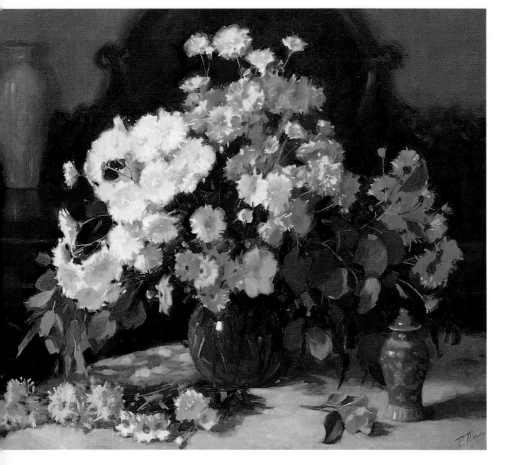

**Early Chrysanthemums**

*36" × 30" (91 × 76 cm)*
*Chrysanthemums don't die quickly and are a godsend! How else would I have gotten all those little shapes drafted in? Mums are so good you can often prune them down and mix them with something else for another painting.*

### Camellia and Chrysanthemums

*20″ × 16″ (51 × 41 cm)*
*One flower will do it. There just happened to be one camellia in the garden. Add some shortened chrysanthemums, some foliage from the garden, and there's a painting.*

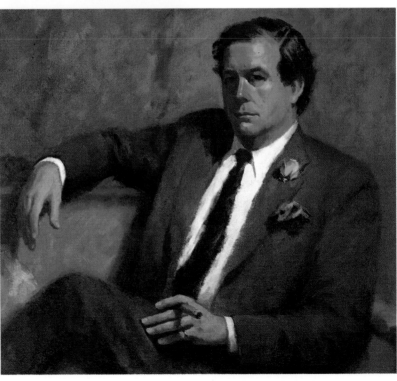

**Detail.** *The rose is one that he grows himself.*

### Mr. Richard Holdaway

*34″ × 30″ (86 × 76 cm)*
*Flowers can enhance many kinds of painting. Isn't this rose in the lapel the icing on this portrait?*

## Chapter five

# Arranging flowers and setting up a still life

My definition of fine art is painting Nature exactly as it is. Nature has its own poetry, and I defy anyone to beat it. This is easy to see when painting a landscape. It catches your eye and that's why you want to imitate it on canvas. When painting a portrait, you let the sitter take up his or her own natural pose, and it will still be that person, no matter how many hairdo or fashion changes follow.

Most flowers will settle in a vase in their own way, but there are plenty that don't. The best way to set up flowers is to plonk and run. Get them looking as natural as possible, and close to the way they grow in the garden or on the tree. Of course, that is the ideal; it doesn't always happen. But if you strive for this, then you have a better chance for a good painting than if you set out to torture them into the shape of a bridal bouquet.

Do *not* paint from plastic flowers—*ever*. If you have to practice on something that doesn't move, paint something that doesn't move. Try bread or interesting pottery or just long-lasting leaves. And I do not *ever* recommend painting from a photograph. If you don't have time to complete your canvas, then leave it unfinished. If time is limited, select a smaller canvas. Try 9×5 inches or 15×12 inches—and pace yourself.

*Always* set up the still life with

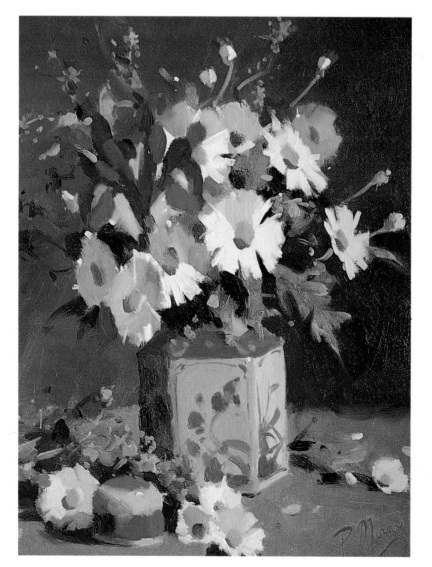

**Iris and Forget-me-nots**

*12″ × 16″ (31 × 41 cm)*
*I don't ever work from a photograph. If I don't have time to complete a painting, I throw it away and go smaller. If time does not permit even this, I go smaller again.*

**Daisies**

*9" × 5" (23 × 13 cm)*
*So instead of a big vase, you use an eggcup.*

**Summer Sprig**

*5" × 9" (13 × 23 cm)*
*Instead of a glass bowl, you use an old perfume bottle—go smaller and give yourself time to think things out. Both of these paintings are very close to actual size.*

### Daffodils!

*36″ × 48″ (91 × 122 cm)*

*My gardener once said, "You plant trees in drifts and avenues; don't just put anything anywhere." That is rather how I arrange flowers. Here I have the stocks together, the gerberas together, and the daffodils together and have a few tie-ins sprinkled around. There are some daffodils in profile to explain the flowers and some long stalks as a further explanation of how they grow. Just remember: Never set up a still life without the spotlight on—it is a pattern of lights and darks that you are arranging.*

the spotlight on, or on the windowsill at the time of day that you will be painting. If you use sunlight, the light will change every two hours, the same as in a landscape, so you will have to come back at the same time the next day—not advisable for short-lived flowers.

When I arrange flowers I tend to keep them in bunches rather than putting one here and one there. Of course, every arrangement has its own problems, but I find it easier to keep

the ones with the sheer stems such as daffodils or iris until later in the setting up. If they don't go in the right place, you can pull them out and put them somewhere else, but with leafy-stemmed flowers like camellias or roses, it's one out, all out! If this happens more than once, it's a good recipe for a tantrum, and a tantrum doth not a good painting make.

How many variations can you get with the same variety of flower? Well, the flowers make their own statement.

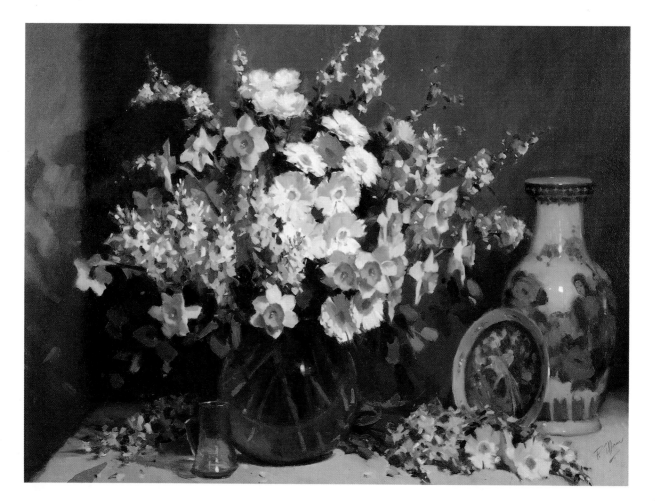

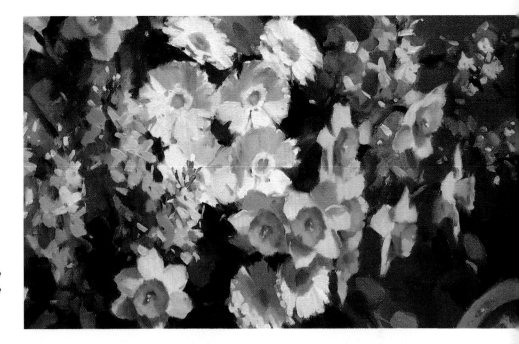

**Detail.** *Here you can see how I explain the daffodils by showing some in profile, some in three-fourths view, and some almost, but not quite, facing the viewer.*

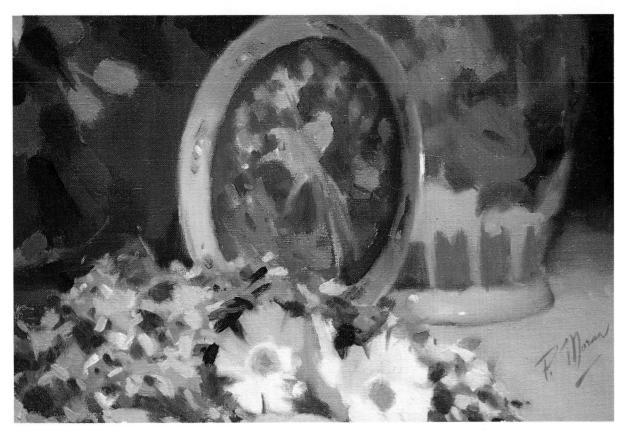

**Detail.** *I usually lay some flowers on the table to tie the different parts of the painting together. Here, the daffodils are the central characters, so I put the quieter flowers on the table so I wouldn't draw interest from the daffodils.*

**Roses in Chinese Vase**

*20″ × 24″ (51 × 61 cm)*
*These roses from the florist were single stemmed and all blooming at the same rate. They looked static on their own, but some chrysanthemums and forget-me-nots sparkled them up a bit.*

## Garden Roses

*20″×24″ (51×61 cm)*
*These roses came from my father's garden and had three or four heads to a stem. They simply arranged themselves. So even though these paintings have similar flowers and are on the same-sized canvas, they are quite different. It is the flowers that whistle the tune.*

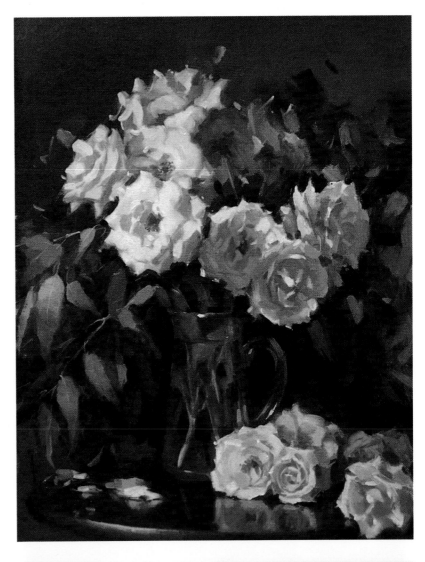

**Detail.** *Roses on the table.*

**Detail.** *Roses. One leading flower, one point of interest.*

Some patterns do seem to repeat themselves, but each bloom is individual, and it's the flower that calls the tune.

With daisies I often buy two bunches. I will chop a few inches off the bottom of one bunch; the other I will leave tall. I take some out as extras and place the tall and short bunches together in the vase. Already they look interesting. The extra flowers either go in the arrangement or on the table or are kept in a cool place in case I need fresh ones, as the ones on the table die quickly without water. They they make themselves comfortable in the vase.

Of course, all arrangements are not always this simple. Many times I have spent hours trying to get flowers to look natural, or trying to stop them from all facing the wall, but you just do your best. To explain which type of flower you have painted, try to get one in profile and one detailed enough so that the others explain themselves. Even with hydrangeas just one little floret on one head will explain the whole painting. And don't forget that *the spaces can be as interesting as the object* in a painting.

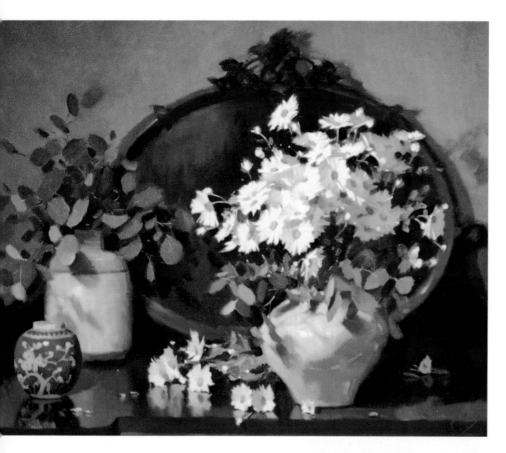

**Detail.** *The daisies.*

**Daisies in Peach Vase**

*36″ × 30″ (91 × 76 cm)*
*Two bunches of daisies, not placed in the vase one flower at a time, but in chunks of different lengths. Then I added some foliage to give the plain vase some interesting shadows.*

Now we strike a problem: how to make a still life look natural. Unlike the landscape that we saw as we rounded the bend and had to paint instantly, the still life is our own creation. The finished product will really show what we are made of. It has to be pure poetry.

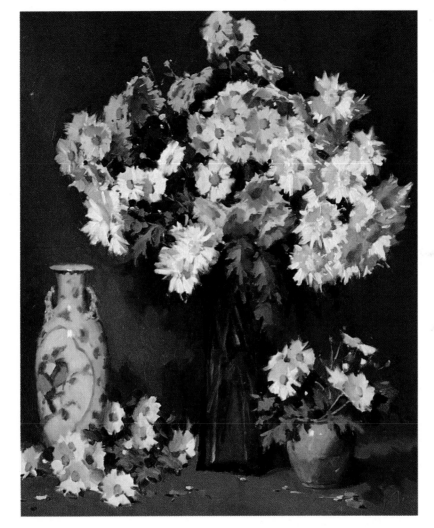

**Chrysanthemums and Bird Vase**

*30" × 36" (76 × 91 cm)*
*This was one of those rare occasions where I plonked the flowers in the vase to be used at a later date and they looked ready to be painted. Even the bird vase was waiting there to be used. I just added some daisies to connect two widely spaced bunches, and I put the spares on the table. The subject just couldn't take another vase, so I had to use one that did a disappearing act.*

# Here are some questions to ask yourself:

**1.** *What is the point of interest?*
There will be one point of interest, and one point only. Everything else is to lead you back to that point. The eye will go to the area of greatest tonal range — the lightest light against the darkest dark, or the brightest color. Everything else should have a reduced tonal range but should still remain interesting.

**2.** *Does the setup look comfortable? Does it look like the subject was already there and you painted it be-* *cause it looked good?*
Have you ever been landscaping and looked across and seen a better subject than the one you are already painting? I have shoved spare flowers in a convenient vase while I got on with the big job, only to find the spares looked better than the main vase. Sometimes when you begin a still life you plonk out all your favorite things, and suddenly — with hardly any adjustment — there's a still life! It happens, but it's rare. However, it *is* this natural appearance that your still life

should have. It can take exhausting hours of rearranging to obtain that ease of balance.

**3.** *Is it too cluttered?*
There's nothing more confusing than too many bits and pieces that look the same. Use a flower or leaf to break that line, not another pot or dish.

**4.** *Are the flowers staring at you?*
Don't have any flowers staring you full on in the face — particularly daisies. Tilt them away from the viewer.

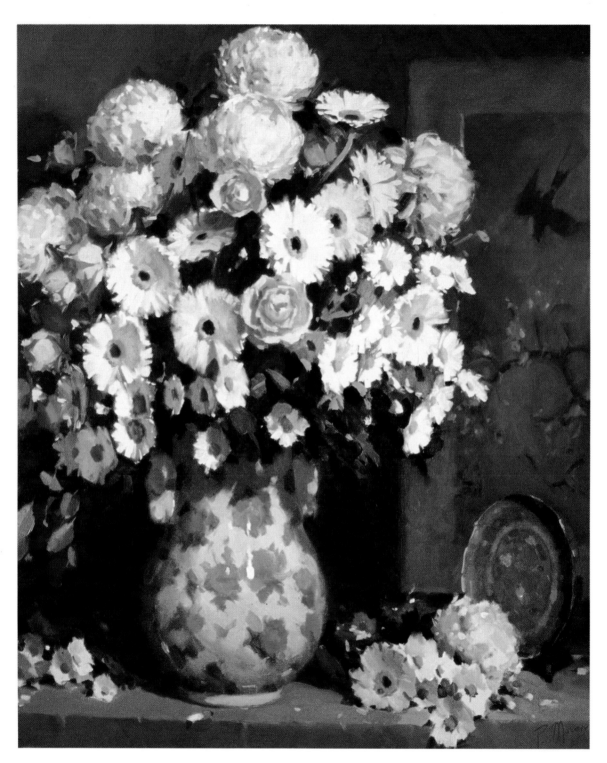

**Gerberas in Blue and White Vase**

*30″ × 36 (76 × 91 cm)*
*Always tilt the flowers away from the viewer. These black-centered gerberas would be very unnerving if they were viewed full on. Instead of your looking at the painting, they would be looking at you!*

# Vases

Since it's the flowers that call the tune if you are doing a flower portrait, everything else has to be of secondary interest. A vase may be used as a means to carry the eye, extend the pattern, join or tie areas together, or set off the flowers. You have to ask yourself, "Am I painting the flowers or the vase?" The answer lies entirely with the pattern of lights and darks that you have arranged, but you can have only one point of interest.

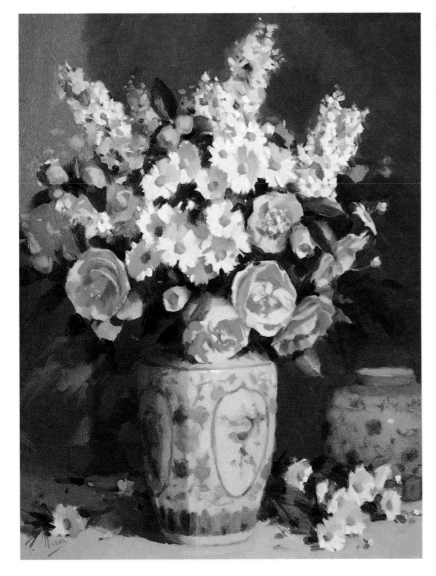

**Camellias and Stocks**

*24″ × 30″ (61 × 76 cm)*
*With these long flowers going straight up without any shadows to soften the line, a plain vase could have been a large unbroken mass that would have attracted more attention than the flowers. This vase with a pattern slightly softer and smaller than the flowers gives continuity without being too sudden.*

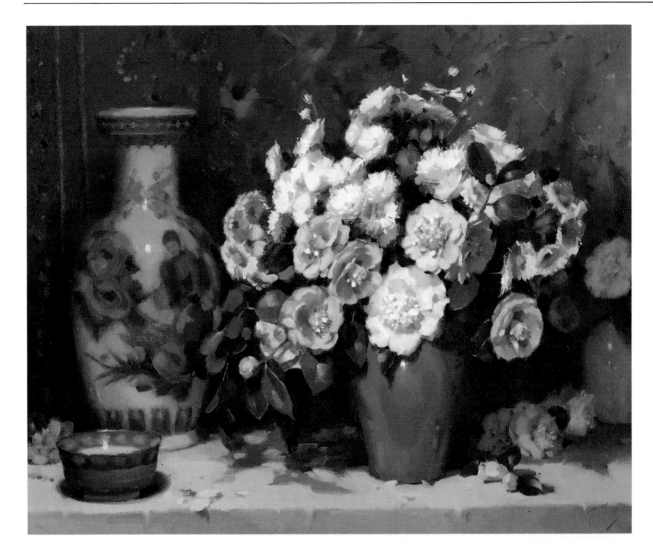

**Camellias and Chinese Vase**

*36″×30″ (91×76 cm)*
*This plain red vase, rather than taking the eye from the flowers, actually sets them off, a great foil for the white camellia and dark green leaf. The red is then picked up in an ever-diminishing pattern across the canvas.*

**Calendulas and Fresias**

*24″×20″ (61×51 cm)*
*This vase pattern repeats the centers of the top flowers, and if you squint at the second vase containing the orange flowers, it does the same.*

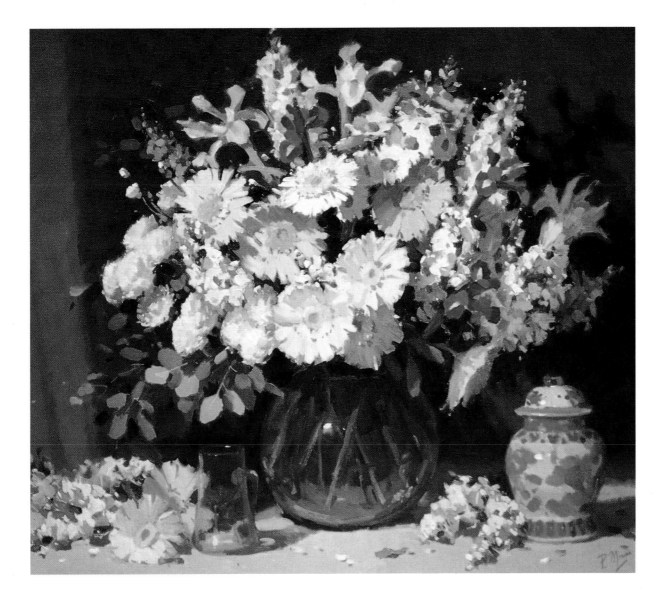

### Yellow Gerberas

*38″ × 32″ (96 × 81 cm)*
*Glass, by being not exactly there, allows you to introduce other things without making the pattern too busy.*

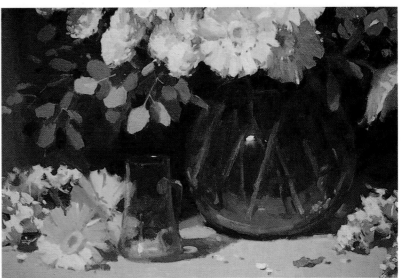

**Detail.** *Glass vases perform a great disappearing act. They support the flowers without actually being there, focusing the viewer's full attention on the point of interest.*

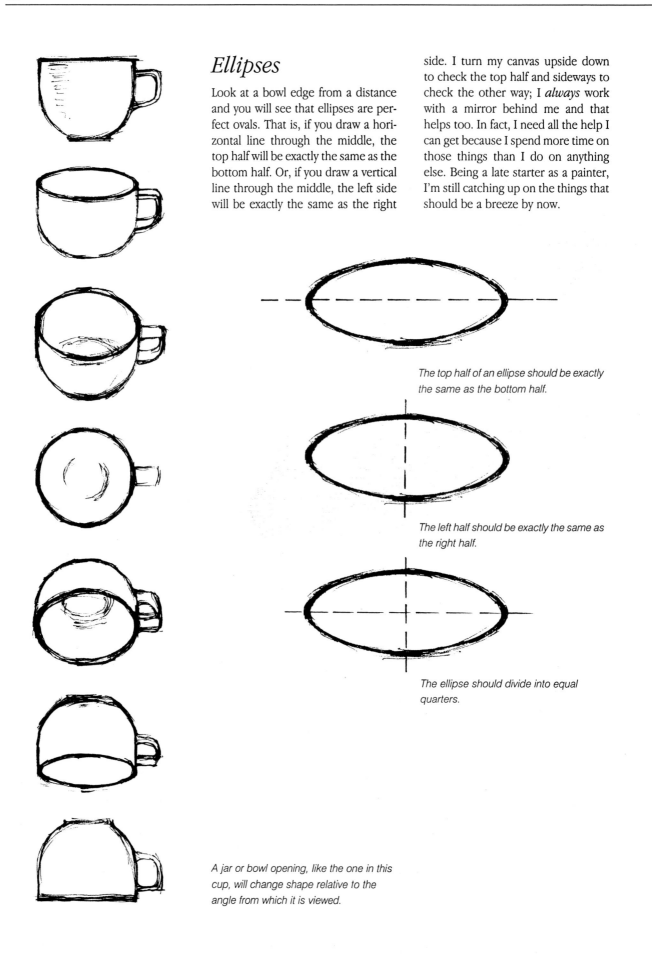

## Ellipses

Look at a bowl edge from a distance and you will see that ellipses are perfect ovals. That is, if you draw a horizontal line through the middle, the top half will be exactly the same as the bottom half. Or, if you draw a vertical line through the middle, the left side will be exactly the same as the right side. I turn my canvas upside down to check the top half and sideways to check the other way; I *always* work with a mirror behind me and that helps too. In fact, I need all the help I can get because I spend more time on those things than I do on anything else. Being a late starter as a painter, I'm still catching up on the things that should be a breeze by now.

*The top half of an ellipse should be exactly the same as the bottom half.*

*The left half should be exactly the same as the right half.*

*The ellipse should divide into equal quarters.*

*A jar or bowl opening, like the one in this cup, will change shape relative to the angle from which it is viewed.*

## Roses

*30″ × 36″ (76 × 91 cm)*
*I am not good at ellipses and this dish had to be checked thoroughly. I turned the canvas upside down on the easel and measured, and looked at it backwards in the mirror behind me to check if the top half was the same as the bottom half. Then I turned the canvas sideways on the easel and measured the side halves. To make double trouble there are two different blue bands around the edge, so I just kept working at it until it reached the stage when its inaccuracies stopped attracting attention.*

**Detail.** *You can see here the advantage of "painting against the form" — not only does it mean you can go for a walk halfway through painting the ellipse, but the softness of the edge attracts less attention than a super slick, accurate one "with the form" would do. A sharp flying saucer down the bottom of the painting would have certainly put the roses in second place.*

## Leaves

Some flowers have very distinctive leaves, and you may have to ask yourself, "Am I painting the flowers or the leaves?" Just remember there can be only one point of interest. Make sure where the interest lies.

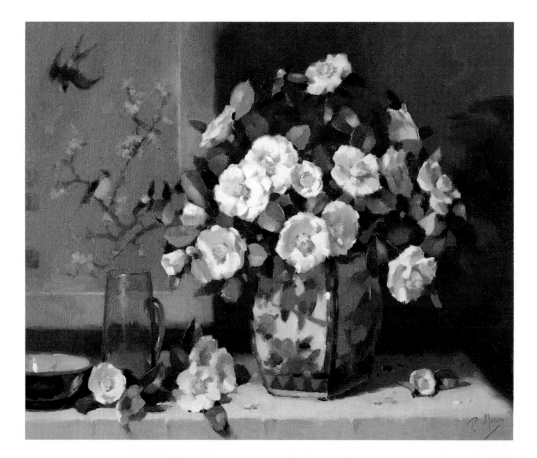

**Cool Beauty**

*36" × 30" (91 × 76 cm)*
*Every winter these camellias are just breathtaking — pure white and flawless. The leaves are setting off the camellias beautifully; the dark, glossy green against the white makes a strong contrast of tone. There is only one leaf in full focus to give the eye the lead, so the brain does the rest.*

**Detail.** *Camellias with leaves.*

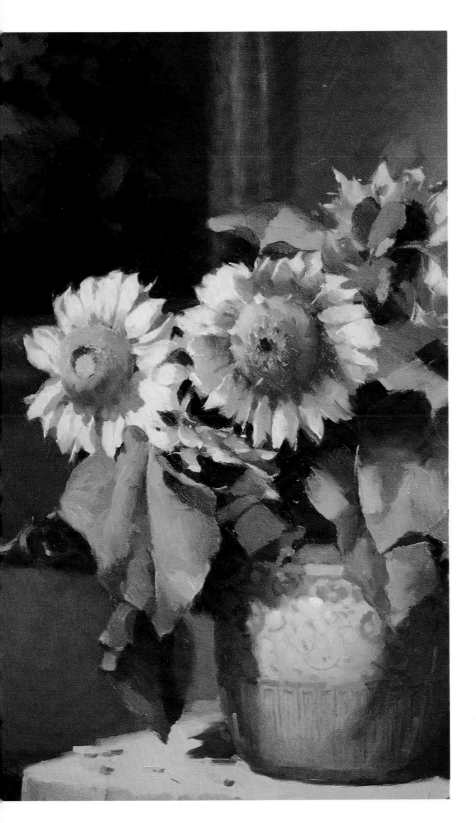

It seems that with sunflowers, the bigger the flower, the bigger the leaf. They just couldn't be ignored, but they still take second place to the flowers because their tonal value is close to that of the background.

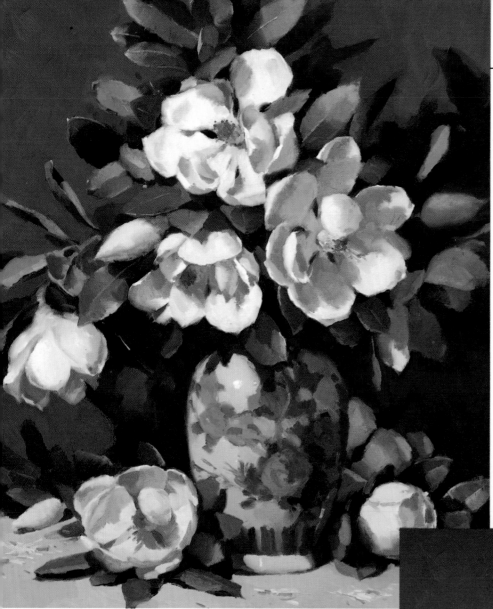

## Classic White

*30″ × 36″ (76 × 91 cm)*
*What can I say — the magnificent Magnolia Grandiflora. The tree was over one hundred years old and the flowers ten inches (25 cm) in diameter. Notice that it is hard to tell the difference between the leaves and the flowers that are in shadow on the right-hand side of the painting. I picked the flowers prepared to cut off some of the leaves; but as they enhanced the flowers rather than detracted from them, I left them on.*

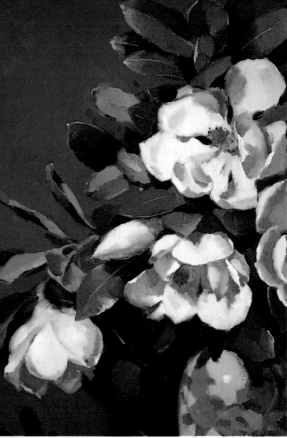

*Magnolia leaves tend to repeat the pattern of the petals. The browny backs and green fronts were explained by the leaves in profile on the left side.*

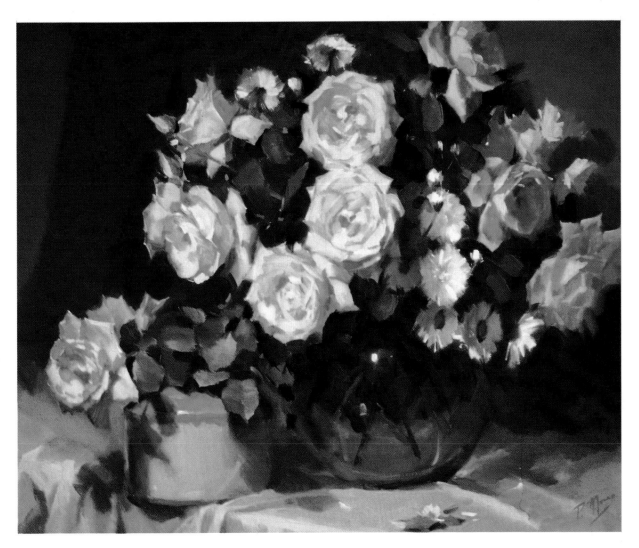

## Peace Roses

*28″ × 24″ (71 × 61 cm)*
*Another example of the tonally disappearing glass vase leaving room for a secondary vase. The leaves here add interest but do not dominate, mainly because their tonal value blends into the tones of the background and vase.*

**Detail.** *Yellow roses. The rose leaf has a habit of lasting just as long as the flower — the rose droops, the leaf droops. You cannot mistake rose leaves. Here, the main leaves, with their glossy detail, make a connection to the flowers and further explain the nature of the growth of the flower.*

# Backgrounds

There are no hard and fast rules about backgrounds; it depends on the point of interest. If a background is too gaudy, too detailed or too busy, it *will* become the center of attention whether you want it to or not. If you work from your standpoint and mix your background while you are looking at your point of interest, it should be just another problem of relative tone/color, lost and found edges, and proportion to be solved like anything else on the canvas.

The background you give a flower painting depends on the complete structure of the painting. As, for instance, painting a commissioned portrait is different from painting the light's effect on your mother knitting, so is painting a "portrait" of a bowl of flowers different from painting a picture of a light effect on a posy placed on the workbench. If you have deliberately set up a bowl of flowers with a spotlight on them and consciously made the flowers the point of interest, then everything else around, including the background, will have to be relative to the flowers.

As it is the flowers that call the tune, the background can be selected for various reasons: to set the flowers off, to tie the pattern together, to give another dimension, or just to balance the lights and darks. It is as much a matter of taste as the selection of anything else in the still life.

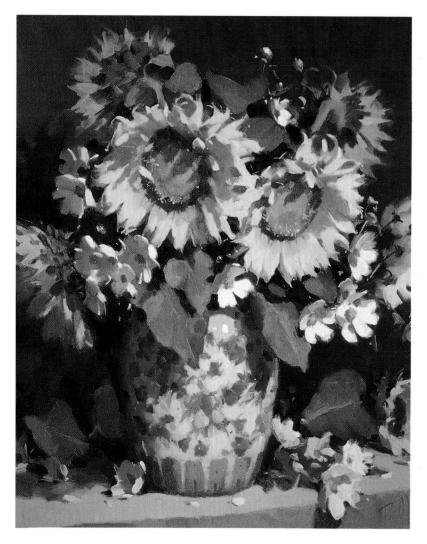

**Yellow and White**

*24" × 28" (61 × 71 cm)*
*This neutral, darkish middle-tones background was selected to set off the flowers. This was simply a "portrait" of sunflowers, but had they been placed with other things in a bigger canvas, a different background may have been used.*

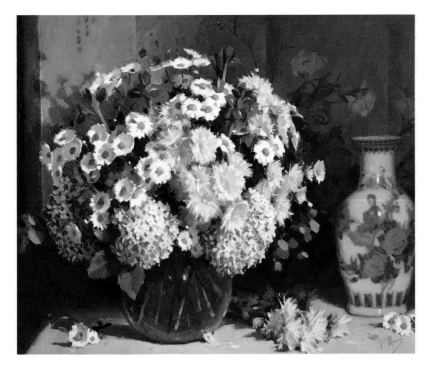

### Blue and Gold

*44" × 36" (112 × 91 cm)*

*Though the two paintings on this page look similar, the near opposite background colors give each painting an entirely different feel. In* Blue and Gold *the Chinese silkscreen provides an echo of the warm flower color and a connection to the subject because of the bunch of flowers above the blue and white vase. The overall pattern adds some gentle interest to an otherwise flat area. In* Chrysanthemums in Copper Urn *the patterned background was selected not only as a tie-in between the flowers and supporting objects, but to soften the outline of this rather formal arrangement. The blue color gives a cool contrast to the bright yellow flower centers.*

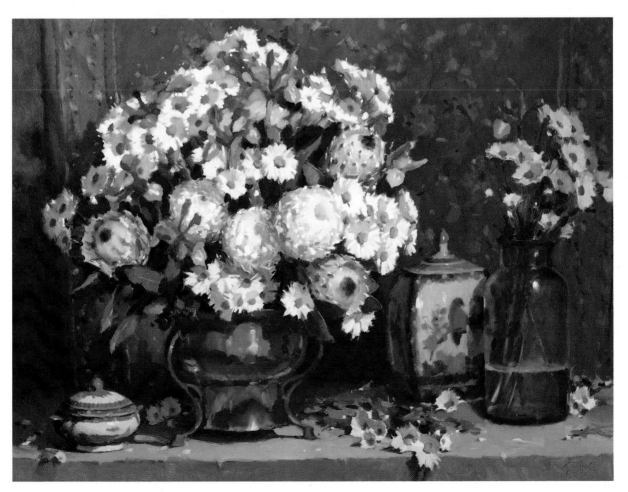

### Chrysanthemums in Copper Urn

*48" × 36" (122 × 91 cm)*

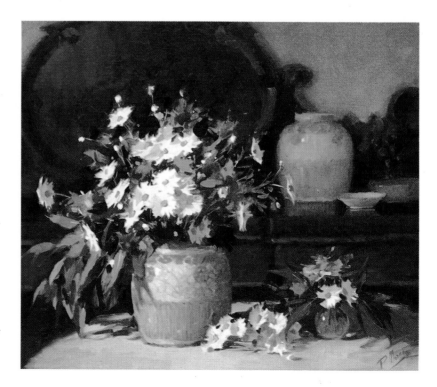

## Pastel Shades

*30″×36″ (76×91 cm)*
*The landscape print pinned to the top left-hand corner was used for several reasons:*
*(a) The dark tones gave more contrast (therefore more interest) to the main flowers.*
*(b) It broke the solid mass of mid-tone background, which didn't seem to relate to all the busy bits below.*
*(c) It added another dimension to the flat wall behind the flowers.*
*(d) As the whole painting is a pattern of circles (flowers and vases), the vertical border of the print made a secondary L-shaped pattern which gave an anchor to the painting.*

## Daisies and Ginger Jars

*28″×24″ (71×61 cm)*
*The antique sideboard not only gives an added dimension and feeling of space, but the dark area next to the white area (the darkest dark touching the lightest light) makes the daisies the point of interest. The edge of this dark area nicely rounds off the top left-hand corner, keeping the eye in the painting.*

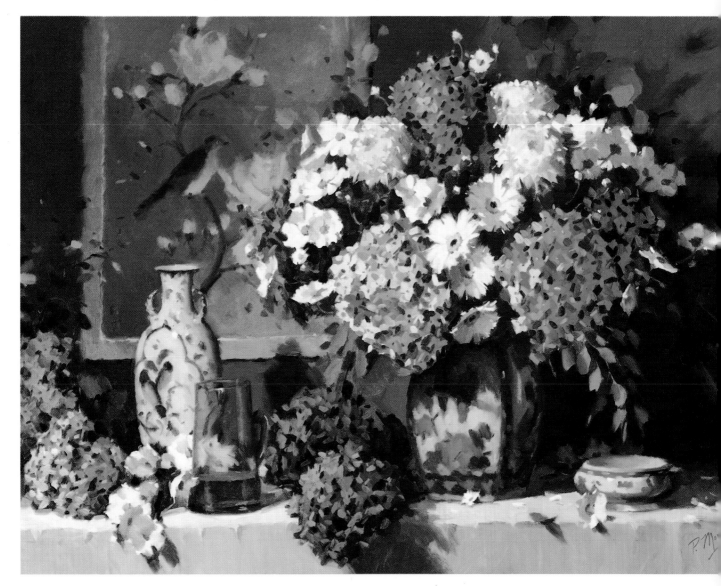

**Oriental Touch**

*48" × 36" (122 × 91 cm)*
*I went mad and put everything in this painting, but if you squint at it, you see that in fact it is a strong continuous pattern of lights and darks. There was so much happening from the bottom left to the top right that something more than a tepid fill-in was called for to balance the top left corner. By depicting what was on the print, the added dimension of what looks like a bird on a branch in a window gives that area more attention than such a tonal range would normally get, thus balancing all the madness on the other side.*

## Lighting the Still Life

Natural daylight, although desirable, is not always practical when painting flowers. Flowers won't wait for the sun to come up so you can paint them. They droop or just drop off in a shower of petals when it suits them — usually at the worst time. I use a 150-watt globe in an old photographers' lamp, and I have only one light source to keep it simple. If possible, the same light should be on both the subject and the canvas.

The setting up of a still life takes a lot of thought. This is where your own poetry comes into play, all the counterchange of tone and color waltzing to your tune. Now all you have to do is get that great vision onto the canvas.

*You can see in this picture of me at a painting demonstration how the same light source illuminates both the subject and the canvas. I find it keeps things simple that way. Note that I am at my standpoint.*

## Placing the Subject on the Canvas

It isn't any good getting halfway through a painting and then remarking with surprise, "Oh, it doesn't look right." You have to *know* it will be in the right position from the beginning, and if it begins to drift off the mark, fix it before it goes too far.

You are *not* looking at flowers, an elephant or an oak tree—you are looking at "a collection of light and dark areas" in different colors arranged in certain proportions and different boundaries of hard and soft edges. Therefore, you have to paint an interesting balance of lights and darks rather than an "object."

How do you get an interesting balance of lights and darks? The eye tends to follow the light. The area of interest will probably be where the lightest light touches the darkest dark, making the light look brighter—thus establishing the point of interest. A large area of dark may be as interesting as a small area of light. *The spaces can be as interesting as the object.* You have to be aware of what constitutes a point of interest and what makes an area of *secondary interest*.

There is a time-honored balance in paintings called the "golden mean." If the area of interest is placed within certain boundaries there is a better chance of the painting feeling right than if it isn't.

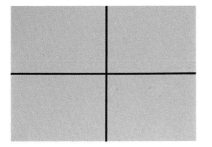

**Step 1.** *Finding the "golden mean." Put a cross in the middle of the canvas.*

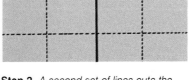

**Step 2.** *A second set of lines cuts the quarters into quarters.*

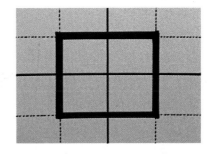

**Step 3.** *This is the "golden mean." Keep your main points of interest within this square, away from the edges, and stay safe. Anyone can dig up exceptions to the rules, but if they work there will be good reasons for their success.*

You are *not* looking at flowers, an elephant or an oak tree— you are looking at a collection of light and dark areas in different colors arranged in certain proportions and different boundaries of hard and soft edges.

## Neutral Areas

Neutral areas support but do not compete with the point of interest. An area where the tonal range is reduced, the color is subdued, and the edges are lost would usually be a subordinate or supporting area. People say, "You can't cut off half a flower, half a bowl, or half a hand." You can't if it is a point of interest. But you can if it belongs to a neutral area. These neutral areas are often outside the golden mean.

There is a tendency among students to set everything well inside the canvas, giving everything a floating ap-

pearance. To avoid that look, it is helpful to recognize from the start that there are some objects that, for the good of the painting, need to be cut off at the edge of the canvas. You have to learn to neither overstate nor understate the neutral areas—to make them neither too captivating nor too dull.

Have a look at the examples on page 59 of the French Impressionist artist Degas. His balance of lights and darks and points of interest are quite easy to see. Now that you understand what to look for in placing that subject on the canvas, let's find out *how* to actually put it on there.

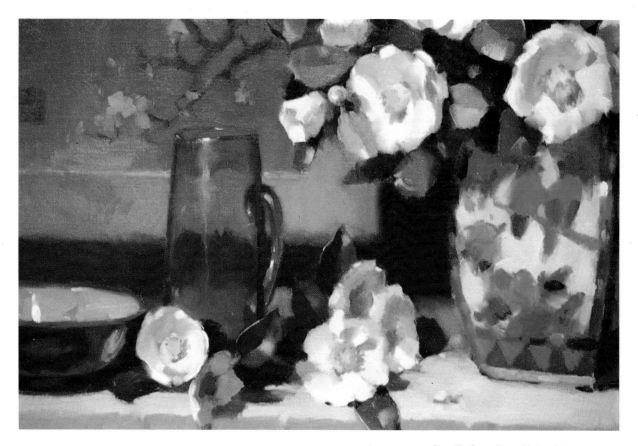

**Detail.** *Camellias with bowl from page 46. How do you cut a bowl in half and get away with it? You cut it off in the area of reduced tonal range and lost edges. The highlight is not cut in half but kept in from the edge. The camellias, the point of interest, are kept within the golden mean. The bowl and screen are the neutral areas outside the golden mean.*

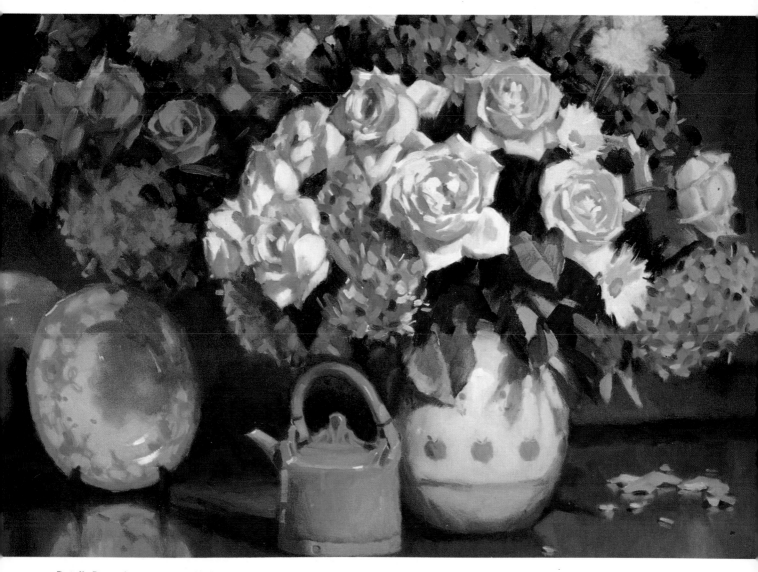

**Detail.** *Roses from page 115. Notice the reflected back of the plate has the edge cut off. It is in an area of reduced tonal range and lost edge compared to the point of interest, the roses. I could not have cut the highlight in half, nor the plate facing the front. If you half close your eyes, you will see that the plate facing the front has a lost and a found edge of its own. The found edge, although not as interesting as the roses or the teapot, is interesting enough to be kept away from the edge of the canvas.*

### Shasta Daisies and Hydrangeas

*30" × 36" (76 × 91 cm)*
*Look at the point of interest, the main daisies, in relation to those daisies at the bottom. So how does the daisy at the bottom get cut in half without it feeling "not right"? Compared to the point of interest they are in an area of reduced tonal range, midtone next to midtone, and the edges are lost.*

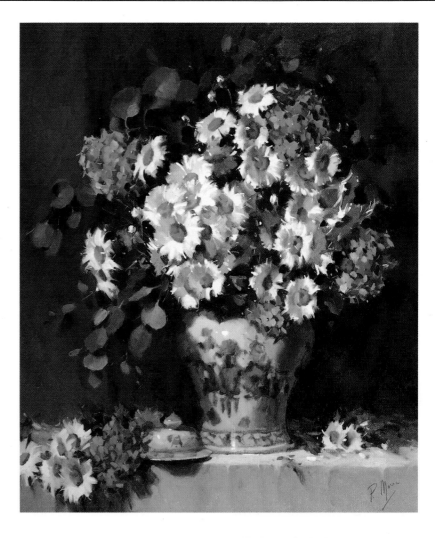

**Detail.** *Shastas near edge. How would it have looked if I had arranged these shasta daisies this way? Doesn't look right, does it? Well, it's not enough to say "it doesn't look right." You have to know why it doesn't look right. Simple. The point of interest is out of the golden mean. It is too interesting to be this close to the edge. Why is it interesting? Because it is the dark that has the most extended tonal range (darkest dark against the lightest light), the hardest edge, and the largest area of this combination.*

*How can these top left-hand leaves be so close to the edge when the shastas couldn't? Simple—they lie in an area of reduced tonal range.*

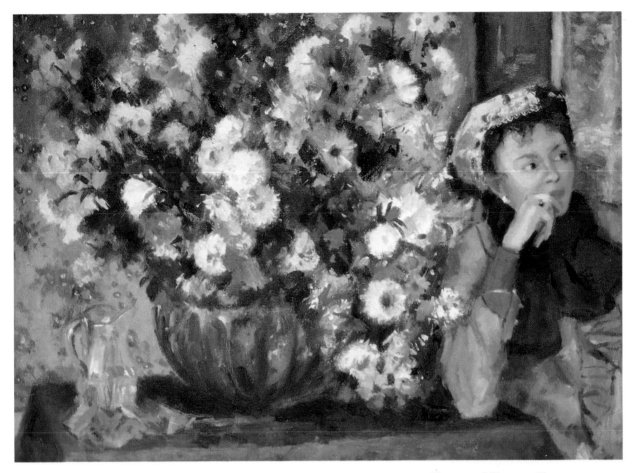

**My copy of *Woman with Chrysanthemums*.** *(Degas, 1865. Original in New York Metropolitan Museum of Art.) The woman is facing out of the canvas near the right-hand edge. Normally this placement would make the sitter look like she's about to leave the picture. Why doesn't it? Because the bowl of flowers on the left side is almost as interesting as the face. Instead of the eye going off the canvas, the flower pattern of lights and darks, and lost and found edges is leading the eye back into the canvas. The left side of the face which is the point of interest (large area with strongest tonal range) is exactly the same distance from the edge as the point of secondary interest (small white flower with the hardest edge, set in a large area of darkest tone) is from the left side. The eye keeps going all around the picture.*

**My copy of *Mademoiselle Dobigny*.** *(Degas, 1867. Original in Hamburg, Kunsthalle.) (I even had the cheek to sign my name on this one!) Another interesting placement. Normally, you would never place a face this close to the edge. It would look like you pruned it to fit the frame. But because Degas has created an area of secondary interest, where the dark tone of the hair is next to the light background, the eye is taken back into picture from the face.*

## Using the Viewer

What you see through your viewer at the beginning is what should be on your canvas at the end. It may not look good, but it will be in the right place. *No drifting off course allowed*. Here are some points to consider:

***What is the initial impression, the point of interest?*** What do you see (gorgeous color/shape/tree/hairdo) when you look through your viewer from your standpoint *and* with your eyes squinting? Write it down if you can't retain it—there's *no* memory like a note.

***Take note through your viewer of certain anchor points.*** Generally speaking a painting is kept *as soft as you can, as neutral as you can, for as long as you can*, which means beginning very, very softly and gradually bringing everything into fo-

cus. Everything should be moveable until you choose to make it permanent. However, with larger or more complicated still life paintings I tend to establish a couple of "anchor points," which are areas that I decide right from the start that I want in a certain position on the canvas to use as an anchor to relate all the other points to.

To begin with, the viewer shape should match the canvas and the subject exactly. I have several viewers in different shapes and an adjustable one with a sliding center. From my standpoint I hold it up to my canvas and adjust it exactly to the shape of my canvas. If I don't have my adjustable one, I readjust something else. I either tear a bit off the cardboard one or put some masking tape down the side of another one, but I get it right. Then, without moving from my standpoint, I check the still life setup; if I am happy with the position of everything I begin to take note of the position of certain key areas within the rectangle.

When I look through my viewer I decide right from the start how I want my picture to finish. I might say to myself, "I want that peach gerbera to finish up just off dead center of my canvas and that dark mark under the bowl to finish up a quarter way up and just a bit in from the left side." Of course, all plans can go awry, but I rub in a pinkish blob in the middle and a darkish one on the left. The other colored patches are placed by measuring their direction and relationship to those marks.

It's highly likely that those "anchor marks" will have to be moved as the painting tightens up, but often they do not. You must *do as much as you can at the beginning of the painting, as there is so much more to do*. This is just my own way of speeding up the block-in process. It may not suit anyone else at all, but it helps me just get *started*. The anchor point could be anywhere on the canvas, but as an example I might ask myself the following questions.

*This detail shows the intricate and beautiful relationships that occur between flowers and between the flowers and other objects. It would be impossible for me to capture this delicate balance without my viewer. You must carry and use your palette, brushes and viewer from your standpoint (ten to twelve paces back from the canvas) until the end of the painting.*

*What mark is dead center of the canvas?* (Imagine cross hairs on your viewer if you don't have them.) Make sure that, from the beginning of the painting to its completion, the center mark is still there, that you haven't worked it off its mark in your enthusiasm. It doesn't have to be a center mark; it could be anywhere as long as it finishes up at the end in the same place that it was in the beginning.

*How far from the edge, top or bottom are those other anchor points?*

**Either put these anchor marks on your canvas or write a note.** Before beginning to paint, I sometimes sketch a square on a notepad and do a childish vase of flowers with captions and arrows; "main flower halfway down," "highlight half-way up, half way in." You will be squinting through your viewer, making all decisions from your standpoint, and carrying your palette, brushes and medium, *right to the end of the painting*, checking on those marks.

In the countryside I have noticed many houses called "Thiseldo." It took me a while to work out that it meant "This'll do." So I say, *No Thiseldos! Near enough is never good enough* (except when you are doing housework). How can you expect to improve if you don't *stretch* yourself? If you aim for mediocrity, you probably won't even get that. So aim to get on that canvas what you see through your viewer, and you won't finish up with your point of interest cut off in the middle of its song. (It *is* a Verdi aria that you are painting, even if it feels like Wagner in the making!)

*White canvas with two anchor marks.*

## Pink and Peach

*36" × 44" (91 × 112 cm)*
*The dark "anchor mark" on the left has now become the base that the pinky vase is standing on, and the pinky dob has now become a peachy gerbera just off dead center where I had decided to place it right at the beginning.*

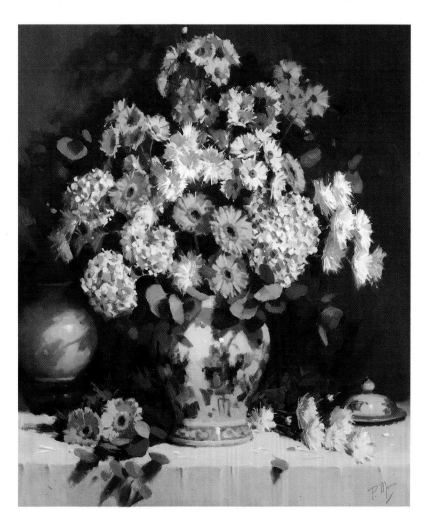

# Painting Flowers Outdoors

Painting flowers outdoors can be a lovely change of pace from painting an indoor still life. You do have less control over the situation—be it a cloud moving over your "spotlight" or bugs finding your medium most attractive—but this is often made up for by the lushness of natural beauty. Painting flowers outside is the same as painting a landscape. The light changes every two hours, so I either complete the painting in that time or come back, same time, same place, same light. (That could mean next summer if I can't match it this time around.)

Follow all the basic painting procedures for indoor painting. As with any painting, your composition is based on a counterchange of lights and darks. Your point of interest should be placed away from the edge, and you need to be aware of lost and found edges.

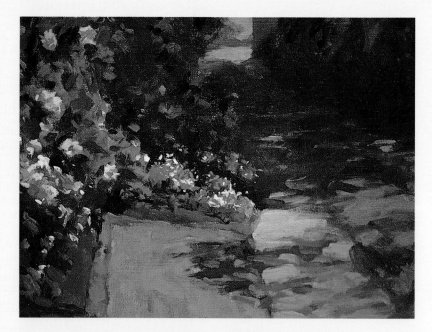

**Detail.** *The point of interest.*

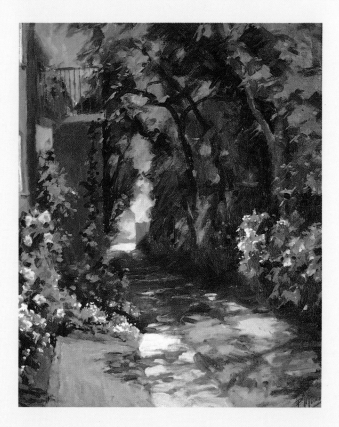

**The Drive in Summer**

*20″ × 24″ (51 × 61 cm)*
*This is a side garden in sunlight. It was done over two days between 12:30 pm and 2:00 pm. Before 12:30 the wall and flowers were in shadow, and by 2:00 they were again in shadow. The point of interest is where the lightest light is against the darkest dark—the little section of garden jutting out—and it is set away from the edge within the golden mean.*

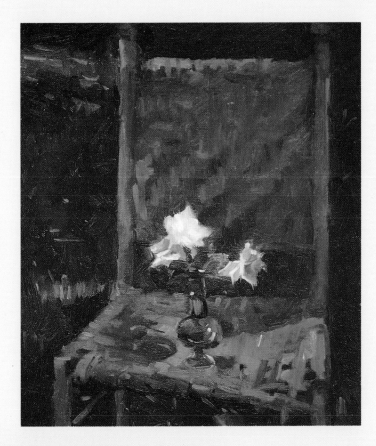

**My copy of *The Old Chair.*** *(John Singer Sargent. The original with the Ormond Family.) This is called "The Old Chair," but if you cover the roses and half close your eye, the tonal range is so limited that the subject would hardly have been worth painting. The light-toned roses, spotlighted by a ray of sunlight against the dark chair, provide the focal point.*

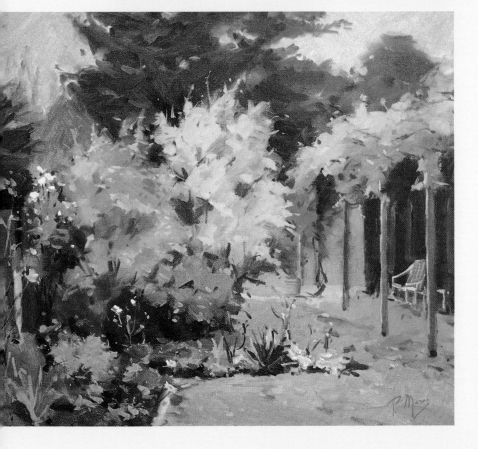

**Country Garden in Autumn**

*24″×20″ (61×51 cm)*
*This was one of those bright grey days when the light wasn't coming from any particular direction. As I was commissioned to paint the garden in autumn I was lucky to have the natural darker tone of the pine trees to set off the bright leaves. I didn't have a choice of day—the leaves would only be there for a week, and it had already rained for six days! So it was now or next year.*

# PART III

# *Painting, Start to Finish*

# A comprehensive guide

Here is a complete step-by-step guide for painting what I consider to be fine art: painting the truth of what you see. Painting is fun but it is work, and you are the one who has to do it. It doesn't matter how good you are, the work still has to be done. I have italicized the catchphrases that I use so you can see how they work in context.

## Let's Begin

Set up the still life. Take your time to get it how you want it. Don't forget to set it up in the lighting you will use for the painting. The lighting is a crucial part of my paintings. Without an interesting pattern of lights and darks, which includes some rich, dark darks and some bright highlights, you will have a flat painting. If your lighting is right, sometimes the painting just seems to paint itself.

Put your canvas next to the subject so sight size equals life size. Look through your viewer and decide what you are going to paint. Note the initial impression and write it down if you can't remember. Stand ten to twelve paces back from the canvas and subject and mark your standpoint. Squint your eyes to eliminate detail and reduce the subject to a tonal pattern of light and dark and of lost and found edges. *Paint what you observe to be there, not what you know to be there.* You are not painting flowers, vases or elephants, you are observing a pattern of lights and darks.

**Detail.** *Central daisies. Even though painting can be an arduous job, it must never look it. These central shasta daisies should look like they were painted with great ease and freshness.*

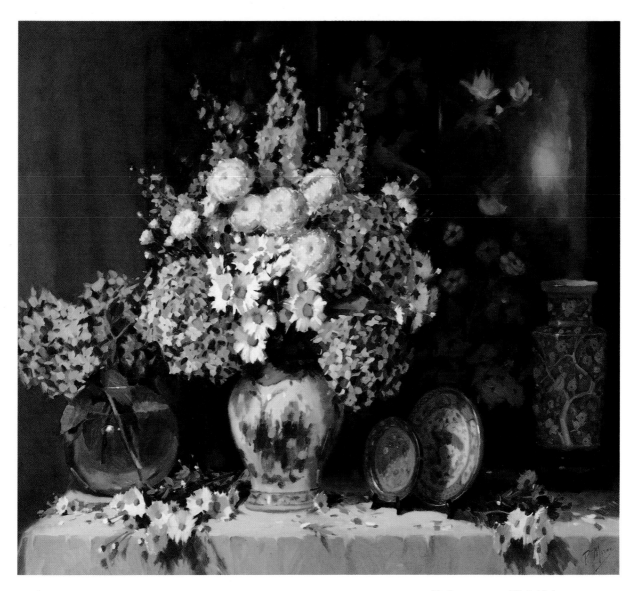

**Hydrangeas and Delphiniums**

*56" × 48" (142 × 122 cm)*
*Setting up a complex still life like this is no easy affair, especially if you are just starting out and don't have a ready-made supply of vases, plates, tables, and all kinds of other items to choose from. If you're just beginning, work small and with just a few objects. As you get the idea of what objects work well for you in a painting, you will begin to acquire things with a "painter's eye." That is, because of their tone, shape, or because they are just interesting.*

*The fully extended tonal range in this painting (from the white daisies to the black screen) gives quite a dramatic effect.*

## Start Mixing Colors

Mix as many tone/color puddles as you can. Begin with probably three for each outstanding area, a midtone, a dark tone, and a light tone. You will have to do plenty of mixing through-out the painting, and remixing as well. Try to eliminate as much as you possibly can at first. You want all that concentration for painting the picture. Use a different brush for every tone/color puddle. You may have fifteen to begin with and finish up with fifty.

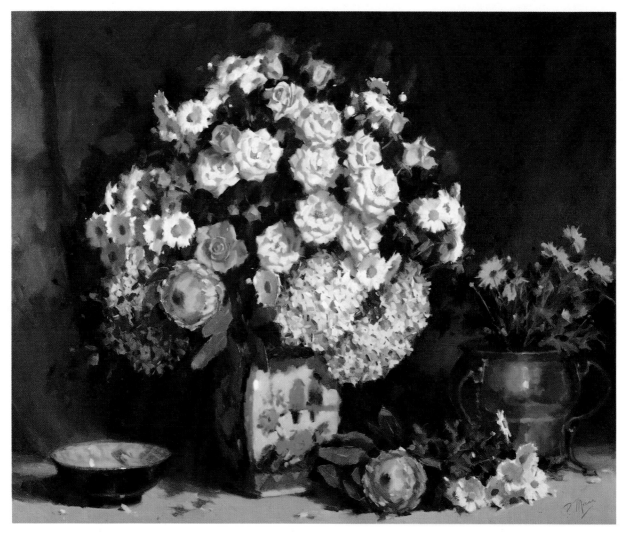

**Roses and Copper Urn**

*44″ × 36″ (112 × 91 cm)*
*You can see how most of this painting remained very soft with only a few places where things are well defined. Big brushes were used for the big area of the background and I used small sables where I felt I needed to break up the hydrangeas.*

## First Marks on the Canvas

An important question to ask yourself is, What is the main difference between the subject and the canvas? Obviously at this stage the canvas is white, and the subject is a pattern of lights and darks. So establish some mid-darks. *A shadow can explain the object.* With flowers, place the brights first. Use your canvas as a lightener. If painting bright colors instead of adding white, use the pure color for as long as you can. (See demonstration in chapter nine.)

Where do you start? You don't have to start at the edge or with the background. If you are painting bright flowers (see demonstration number two), place the bright color first; in a portrait, the flesh midtone; in a neutral still life, place the midtone darks first. However, you must keep the whole canvas moving at once. Don't just place one thing and work on it.

**Camellias and Coffee Pot**

*24" × 28" (61 × 71 cm)*
*The classic beauty of the camellia. I made sure nothing competed with these beautiful winter blossoms. To do that, I made as simple a setup as I could, keeping almost everything but the flowers a dark to midtone.*

## Finish the Block-in

*Cover that canvas as fast as you can.* Eliminate all the white canvas that is not being left as your lightest light — leave that area as it is. Only when the canvas is covered can you judge the relative tones, colors and shapes. *Everything is relative. Make a simple statement out of what you see.* Keep the painting very simple and basic at this stage. Keep your eyes squinted and you will only see it as simple, broad areas to be broken up later.

Always carry your palette with you from the canvas to your standpoint. This includes brushes and me-

dium. They must be with you while you are making your judgments and mixing paint. Now this is where you should be right into the fencing match. For *every* mark you make on the canvas, you *must* step back to your standpoint and check that the mark is correct by: (1) looking across from the subject to the canvas; (2) looking through the viewer; (3) looking with your eyes squinted; and (4) measuring and remeasuring the shape of the tone and color. *Observe for five minutes and paint for one minute* is the type of base to work on — in other words, *more look than put.*

**Detail.** *Notice the bit of yellow at the bottom of the vase. It is reflected light from the sunflower. See how it's not as bright as the flower. Like moonlight compared to sunlight.*

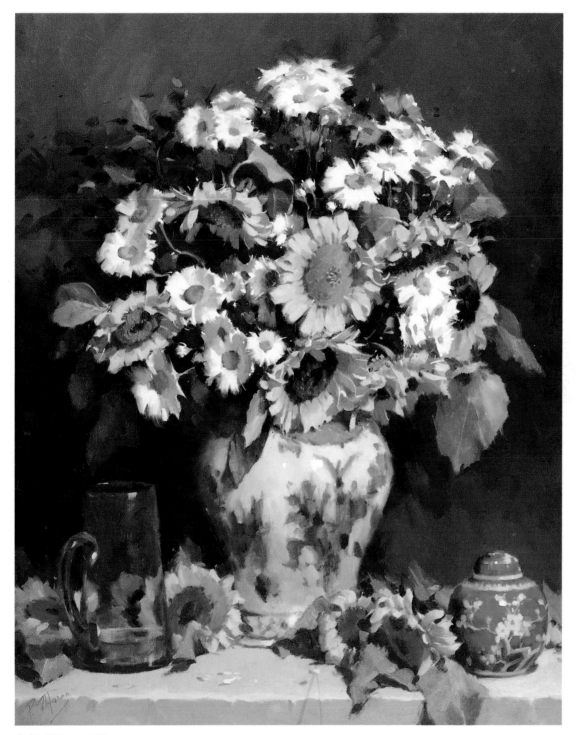

**Gold, White and Blue**

*30" × 36" (76 × 91 cm)*
*If I had not placed my dark tones correctly in the beginning, they very well may have seeped through the wonderful bright yellows of the sunflowers. That's why, when I have a very bright subject, I always place my brights first and make the area bigger than it needs to be. See the demonstration in chapter nine.*

# Lay the Groundwork Carefully

Always paint what is in front of you. Don't change anything on the canvas until you have changed the setup in front of you first. Keep up this standpoint observation until the painting is finished. You are not aiming to paint a picture. *What you have is just a set of problems to be solved.*

*Do not aim for a likeness.* The likeness will appear if you are accurate. That's true for flowers, vases and portraits.

Paint *against* the form. Keep those brushstrokes going in all directions. (See page 21.) *Get as much done as soon as you can as there is always so much more to do.*

*Keep it as soft as you can, as neutral as you can, for as long as you can.* At a demonstration a friend remarked, "Pat looks like she is painting with a feather duster." I couldn't have put it better myself!

Keep asking yourself, What is the main difference between the subject and the canvas? The differences will be of four types: (1) color; (2) tone (lightness and darkness); (3) size (proportions—measure); and (4) hardness and softness of edge. Eliminate one by one the differences between the subject and the canvas. Keep the paint thin at this stage.

*The more you get the groundwork right, the less finishing you will have to do.*

**Chrysanthemums in Oriental Vase**

*36" × 30" (91 × 76 cm)*
*Most of this painting is made of subdued half tones and darks so that the stage wouldn't be stolen from the largest, whitest chrysanthemum. The whites in the second vase and the daisies laying on the table tie the painting together, but because of their smaller size and reduced tonal range, they don't compete with the central flowers.*

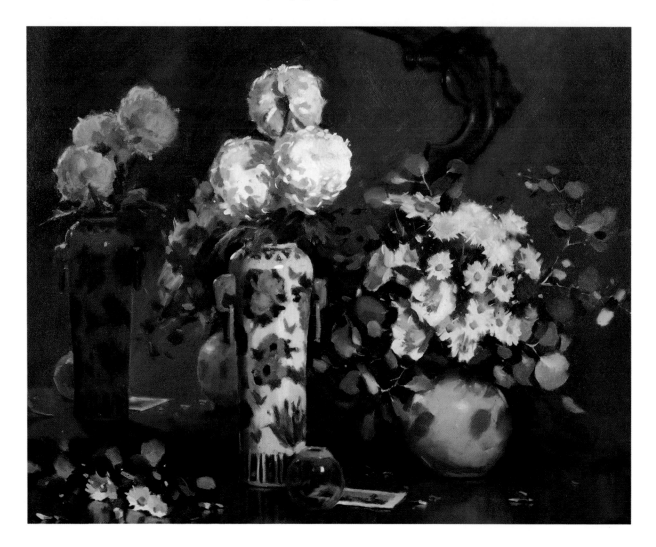

▲ **Detail.** *The one leading edge of lightest light against a large darkish area ensures this flower is the main attraction. There is very little white paint here. Most of this flower is the white primed canvas with just a few darks brought in.*

▼ **Detail.** *These flowers on the table serve a purpose. The top sides of them have lost edges, the bottom have found, thus cutting off the corner of the canvas and taking the eye back around the painting for another trip!*

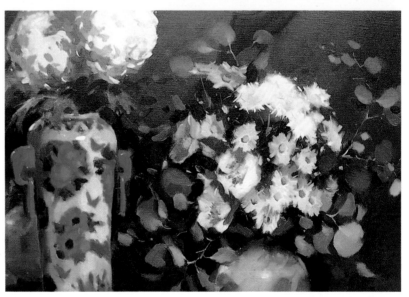

▲ **Detail.** *Even though the flowers in the second vase are many tones darker than the main ones, they must not look dirty; they must look like they are fresh flowers in shadow.*

## Start Painting Over the Block-in

When you consider the block-in complete (when everything is in the right place), add stand oil or oil painting medium to the turpentine. Do all your changing before this. You still have the chance to alter the setup before adding the permanency of oil—and getting to the next very important step.

Establish your lightest lights and darkest darks and those all-important midtones. The dark tones have to be in the right place from the bottom up. If they are not, they cannot be painted over with a lighter tone because the dark tones will eventually begin to appear through the lighter paint.

Watch the tone of the reflected lights. *Reflected light is like moonlight compared to sunlight*—never as bright. Everything on the dark side is darker than the light side. Remember, no camera can split the tones like the human eye can.

Don't forget: *Big brush, big area; small brush, small area.* This not only helps cover the areas in the right proportions but will help with brush selection when you have to go back to a brush—you know you didn't use the size 14 broom for the eye highlight, or the size 1 sable for the background.

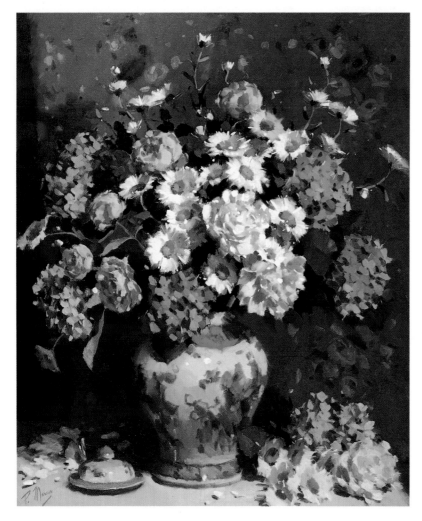

**Peonies with Blue and White**

*30″ × 36″ (76 × 91 cm)*
*This would have to be the epitome of the floral piece, but although there's freshness and bubble there's also strength and stability. This much froth without an anchor could give florals a bad name.*

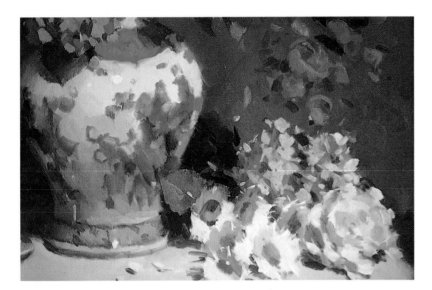

**Detail.** *Flowers on table. How do you cut a flower in half or get it so close to the edge successfully? When it is surrounded by a similar tone.*

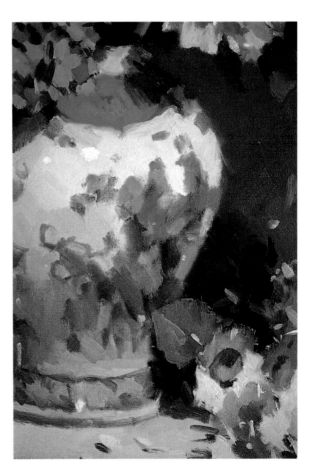

**Detail.** *Flowers. What a shame they come so briefly each year. If you blink you miss them. How much better to have them forever on canvas!*

**Detail.** *Vase. As you can see here, no attempt has been made to "paint porcelain"; it just arrived when all these tones were put together. There is so little paint on that middle blue area that you can see the grain of the canvas through the wash of paint.*

# Make Corrections

Try to establish from your standpoint, with your eyes half closed, *what is attracting too much attention and what is not attracting enough attention.* Crude marks that don't explain themselves can attract too much attention because they don't look right.

There is a traditional saying regarding portraits: *Paint the hands while looking at the face.* This applies to still lifes and landscapes as well. In other words, don't lose sight of the point of interest and overwork areas of less interest.

**Hydrangeas and Gerberas**

*48″ × 38″ (122 × 96 cm)*
*How could anyone resist painting these. These late summer hydrangeas on the right were so rich in color I thought the florist must have sprayed them. I certainly wasn't going to paint anything that had been fiddled with, but they really were natural. The copper pot took some of that strength of color down to balance the painting. Each color and each stroke must relate to the whole painting.*

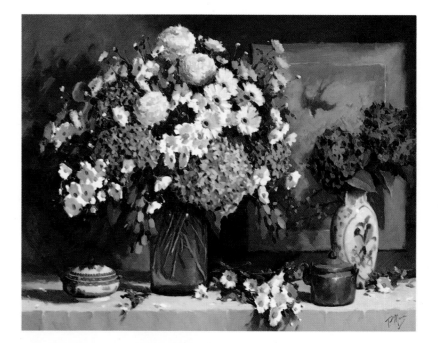

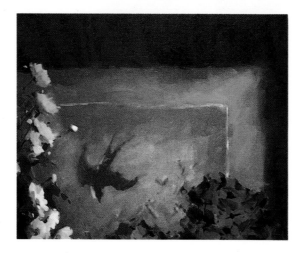

**Detail.** *A good example of a lost edge here; sometimes this can be rather hard to achieve. I check in a mirror to double the stand-back distance to see if the edge is too hard. You can't beat standing back—across the room if necessary—for checking the painting.*

## Check for Confusing Areas

Don't forget, even in those "lost" suggested areas, that those suggestions must explain themselves. The viewer cannot be left wondering, What *is* that bit over there? By all means keep it broad, but it must explain itself. Check if there are any areas that repeat themselves. Don't paint four puffy clouds the same in a row or four hills, trees, cows or flowers. Look for variety.

Check to see if there's anything in the painting that resembles something else. For example, a friend thought he had painted the best landscape he'd ever done. He was very excited and couldn't wait to show it to his wife. He stook expectantly while she looked at it. "That rock looks like a frog," she said. It didn't matter what he did, the rock just went on looking like a frog. He couldn't sell the painting, and it eventually just disappeared; it was called "The Frog Painting." Do your clouds look like cupids' faces or do the folds in the material resemble anything that they shouldn't?

**Detail.** *Flowers. Those long stems with buds cannot be placed over heavy paint. I keep the paint thin for these areas, and I also get a rag and use my fingernail to rub the stalk out first. That gives me a clear run.*

**Detail.** Sunflowers. Big brush, big area; small brush, small area. *These flowers, particularly the one on the left, would have been placed with a size 6 or 8 hog hair, and the little marks with the No. 2 or 3 sable. Those little marks would have looked very crude if I had used a size 8 broom.*

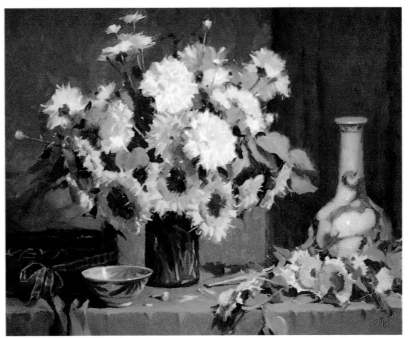

### Sunflowers and Dahlias

*36" × 30" (91 × 76 cm)*
*These sunflowers with the dark brown and gold centers needed some cheering up. The dahlias added some height and a lighter tone and gave the arrangement the "good morning" look that the sunflowers had on the bush.*

## Keep Your Painting Fresh

*It is not what you paint but how you paint it.* I will repeat this until I turn purple! Pickiness, slickness and carelessness will be viewed uneasily. A combination of freshness, tenderness and ease is more comfortable to look at. *Paint what you love and love what you paint.* My mother said, "If you have to work, don't look it!" She meant, of course, don't greet the guests with your apron on, but I apply it to painting.

The completed painting must be uplifting in its ease of application (not sloppiness). Even if you were on tranquilizers, and completing it was worse than a world war, it must never look it. To keep my paintings fresh, I take many breaks. At the beginning you can work longer; then the breaks become longer and more frequent. As you become tired you have to concentrate more to keep it fresh and correct—which makes you even more tired. For a portrait I set an egg timer for twenty minutes. For a still life I set it longer—an hour to begin with, then three-quarters of an hour, then half an hour, and more tea, as I become tired.

In the flower season, when everything blooms at once, I keep working until I go that funny grey/green color. It's very hard to maintain freshness day after day. The tiredness comes from working on that freshness. Watercolorists don't take so long to do a painting; their make-or-break point becomes apparent sooner. However, with a large still life or portrait four feet tall or wide there is also the sheer physical effort of covering that canvas, and fast. You may not know for a week whether it's going to work, and *a painting is only as good as its worst point.*

*Maintain that initial impression* by working with a mirror behind you or by using a hand mirror. The reverse image is great for giving a fresh look and for showing if the painting has a windward or leeward list.

**Detail.** *Table area. This area repeats the pattern of the flowers. The tonal range here is much lower so it isn't more important than the point of interest (the main white flowers), but when a large painting is hung at eye level, the eye does tend to fall more to the bottom than the top. (By the way, never hang a painting over a working fireplace—they get damaged.) So even though this area is not the point of interest, it doesn't do to disregard it and make it sloppy.*

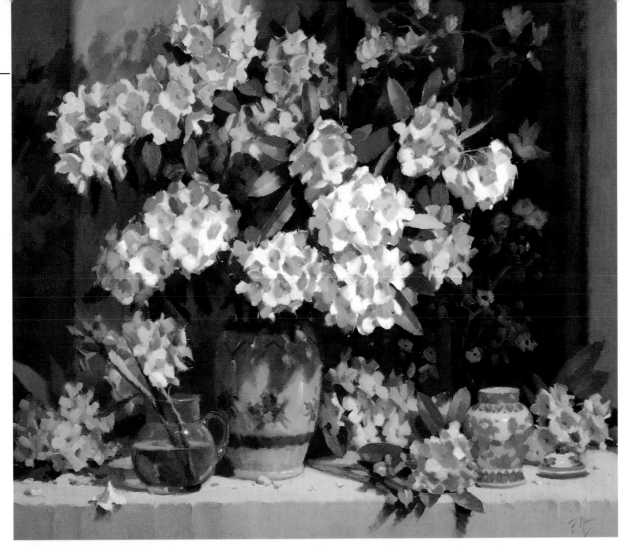

## Rhododendrons

*54" × 48" (137 × 122 cm)*
*These are a mixture of Pink Pearl and White Pearl. The White Pearl start pink and go white, which makes them look very interesting. All white could have been a bit boring. The blue iris and blue and white vase just take the repetitiveness away and give a little surprise!*

**Detail.** *Flowers. Even though the flowers appear pale they do contain some strong tones. With this arrangement I have been able to describe all facets of the flower, including the way the leaves fan out behind the flower head.*

## Getting to the Finish

As you near the finish, and you are putting those last sable flicks in, *relate every brushstroke to the whole painting*. The whole canvas is one unit of tone, color and proportion. As you get to the detail, ask yourself how that tiny sable mark fits in that big sea of brushmarks. For example, is it lighter, darker, brighter, warmer, cooler, straighter, thinner, and so on than those other marks on the canvas? *Is it attracting too much attention or not enough attention?*

*Don't count on "happy accidents."* You should be able to rub off that painting and reproduce the whole thing again. Never just throw and pray—unless you're cooking. You will be glad you practiced all these things when you get that commission to paint the Pope. He won't sit as still or as long as your Chinese vase, so you'll have to draw on all your resources. A concert pianist doesn't have sheets of music. He has practiced so much he knows every note by heart. So it is with the painter; you won't have time to be looking up your notes when you are doing that big job. It has to be all in your head.

If you decide you don't like the background or anything else, don't just alter it on the canvas, alter the setup. Take down the purple backdrop and replace it with the soft beige one, then paint what is in front of you.

Keep the finishing touches in their right perspective.

*The signature is part of the painting.*

**Roses and Blue Hydrangeas**

*54″ × 48″ (137 × 122 cm)*

*If the blue and white vase on the left side of the painting had not been as strong, the eye would have stayed around the main vase area, thus giving the feeling that the left would be better cut off. The rose is the point of interest. Then the eye goes to the vase on the left as the secondary point of interest (I don't feel there's a competition here) by-passing the birdie vase, which had to be eclipsed so the eye would wander off to enjoy the copper pot and the flowers on the table. Then the birdie vase appears to the viewer, and the book rounds off the corner and sends the eye round again. All this is designed to keep the eye inside the painting—you see, there is method in this madness!*

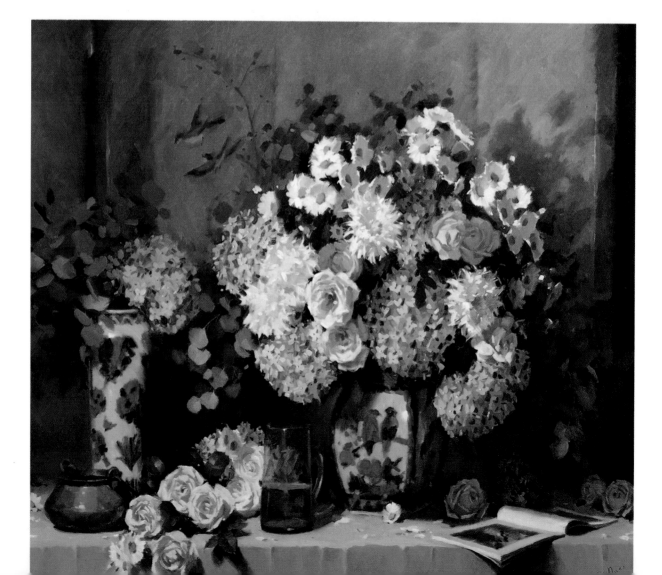

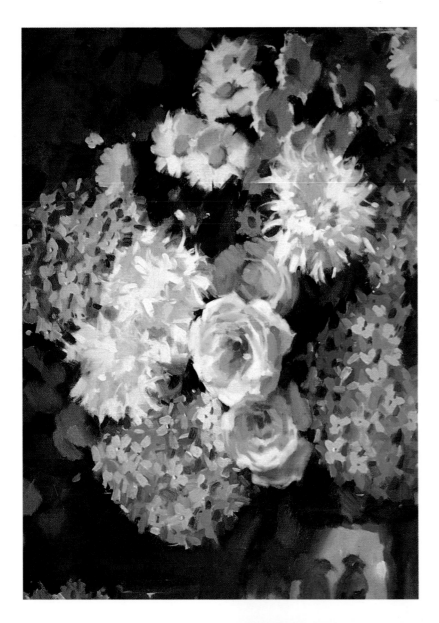

**Detail.** *Flowers. Even in this large painting, everything is secondary to this one yellow rose.*

**Detail.** *Screen. A size 10 or 12 hog hair would have been used for most of this screen—it is a large canvas to cover. A smaller brush would have brought it too much into focus.*

# PART IV

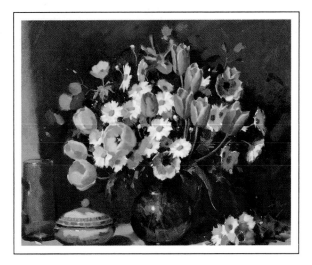

# *Painting*
# *Demonstrations*

# *Beginning with a neutral tone*

## *Demonstration*

For the first demonstration I decided to begin the painting in a neutral tone. Many tonal realist painters begin this way and it is a good way to understand that you are painting a light effect on objects, *not* the objects themselves. Alter the light source and a different pattern of lights and darks will appear.

To paint the block-in with this method, squint your eyes and look at the subject. Then with one neutral midtone establish the shadow areas, leaving the light areas untouched on the white, primed canvas. *The shadow will explain the object.* If you mix with your eyes fully open, the local color will take precedence over the tone. Remember, the correct tones are number one in establishing the truthfulness of a subject. Think tone.

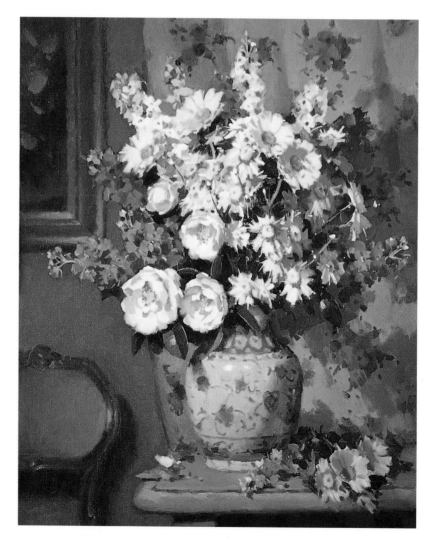

**Pastel Shades**

*28" × 36" (71 × 91 cm)*
*To the right you see the steps that led up to this full color painting. I have added color and detail but the tonal values have stayed consistent with my neutral-toned block-in.*

Here I apply one neutral midtone for the shadow area, and a vase of flowers is already appearing. Here you can see how the shadows explain the object.

I add the darkest darks, again in a neutral tone, and there's no mistaking what's beginning to take shape. This is a tonal picture. Now these tones have to become color.

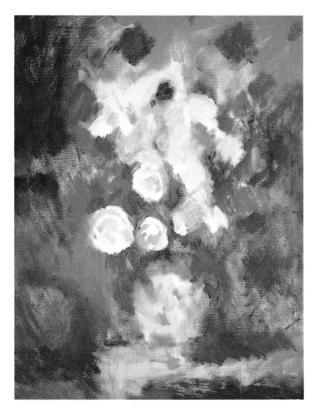

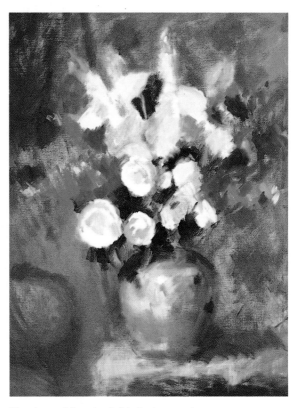

By observing from the standpoint and keeping the eyes half-closed while mixing the colors, you will be able to see the tone take precedence over the local color. As I add some local color, I take care that the tonal value of the color matches the tonal value that I see with my eyes half closed.

Here I am adding stand oil to the turps and establishing the darkest darks. You can see that there is a dark green and a dark purple; different colors, the same tone.

# *Flowers in a patterned vase*

*Demonstration*

Painting anything patterned—a vase, tablecloth, backdrop or dress—in a portrait is a problem that tends to be avoided, either by just excluding anything with a pattern, or by leaving the patterned areas until last, then sort of glueing them on when the easy bits have been done. Wrong. You are painting a counterchange of lights and darks, not a patterned vase, dress or elephant. *You are not aiming for a likeness of anything; you are aiming to solve a set of visual problems* in order of appearance. If it happens that you have a patterned vase in front of you, and it happens that your painting has a patterned vase when you've finished, then you have solved the problems.

**Step 1.** *First mark on the canvas. Looking through my viewer from my standpoint and observing the pattern of lights and darks, I take note of certain anchor points. Specifically, I am taking note of a dark mark that is at the dead center of my canvas. I am going to use that mark as my anchor and measure everything from that point. I hope it will still be right there in that position at the end of the painting and not drift off that mark.*

**Step 2.** Make a simple statement out of what you see. *With my eyes squinted and observing only the obvious masses of lights and darks (no details, no boundaries), I cover that canvas as quickly as I possibly can. Because all the marks relate to each other, you cannot make relative decisions until the canvas is covered.* As there is always so much more to do, *get this business out the way as fast as your brushes will go. Using only turpentine as a medium I try to keep the work* as soft as I can, as neutral as I can, for as long as I can. *Note that the dark mark in the center has been strengthened.*

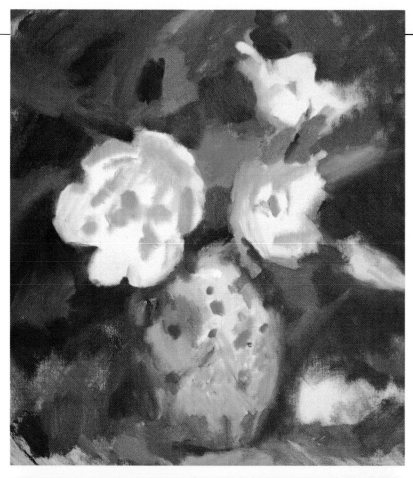

**Step 3.** *Keep the whole canvas moving. Because* I don't work on any one area for too long, *the painting is looking like an out-of-focus photograph — everything is there, it just can't be seen properly yet. The details are beginning to appear in every area at the same time, which includes some simple marks on that midtoned area called a vase as well as simple marks on the flowers and leaves. Do not paint the vase as a separate unit and glue the pattern on last. Work across the whole canvas. While you have a brush in your hand, see where else you can use it. Establish highlights early as another anchor.*

*If you are wrong, can you rub it out? You certainly can. Now is the time to do it, while you are still using turps as a medium. I spend an age rubbing it out. I never seem to get it right, but I just keep rubbing and adjusting. I won't get into oil until I get it as right as I can. Needs more work.*

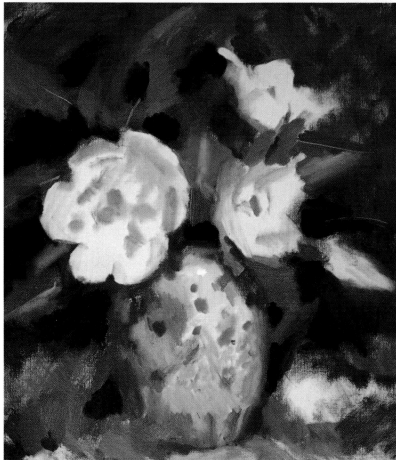

**Step 4.** *Establish the darkest darks and the lightest lights. Now I add stand oil, making those darks so strong and rich already the painting leaps. I make sure those anchor points are still where they should be and begin to work across the canvas. The oil is a permanent medium, so those dark areas have to be in the right place.*

*Because these darks tend to look sudden when first placed, there is an inclination to knock them back. Don't. If you kill those lovely pure darks, the whole painting will drop dead. When the midtones are added those darks will blend in.*

*The highlight on the vase is the lightest light. Now the full tonal range is established. You cannot go lighter than the highlight, and you cannot go darker than the darkest darks, which could consist of viridian, ultramarine black or Alizarin crimson. That's the easy part. It's the midtones that cause all the problems, and they generally make up the largest area of the painting. I am using the white canvas as my light and working my tones back from that. Sometimes I leave areas of my prepared canvas untouched.*

There has been only one thing added here, the midtone of the background. It has blended in with some of those dark tones so they don't look so sudden, and the impact of these flowers is beginning to show.

Now going back to the point of interest, that large area of light tone. More alterations on the vase area, but its all part of the job of adjusting and readjusting the whole painting. As soon as you alter one thing you have to alter everything—usually back to where they were in the first place.

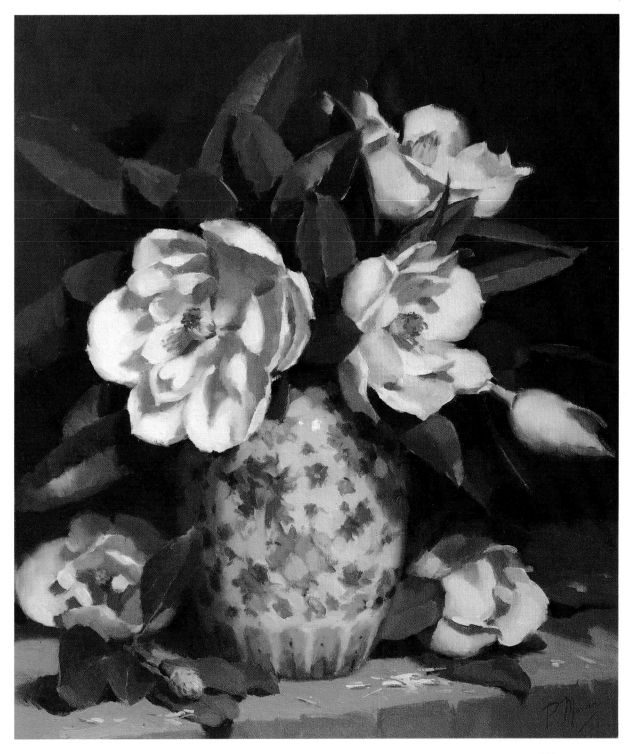

**Magnolias in Patterned Vase**

*24″ × 28″ (61 × 71 cm)*
*The important thing to remember about painting a pattern, whether it's on a vase, tablecloth, wall or floor, is to treat it like all the rest of the painting. It is only a pattern of lights and darks sitting there relating to all the other patterns of lights and darks in the subject.*

# Unusual flowers and bright colors

*Two varieties of late winter wattle. The trees virtually explode with fluffy yellow sunshine. How do you handle this without getting dotty—or going dotty!*

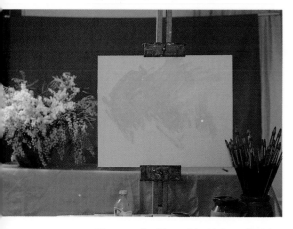

*Photograph of the subject taken without a flashbulb to show the light's effect on the flowers. The canvas is placed exactly beside the subject. I am painting life size and sight size.*

## Demonstration

We are using the Australian native flowers as an example. The Australian native flowers have unusual properties. At a distance to the unaccustomed eye they are a puzzle. Their beauty is revealed mostly at close observation, which can make them a problem for the painter to explain on canvas. The popular ones, such as the golden wattles, the scarlet summer flowering gums and the bottlebrush, have no petals but consist instead of a mass of tiny, soft, feathery stamens, often tipped with a different color from the flower. The stems, red or green, often have a white dusty coating that gives them a frosted appearance, and the leaves, which are sometimes similar in color to the South African protea, can go from dark green to light grey blue.

This demonstration of painting wattle is not only to show you how to approach any unusual flower, but to cover another area that comes up with some European and oriental flowers such as tulips, sunflowers or camellias: color, or "brights" as I was taught.

Try this test. On a white primed canvas rub some pure cadmium yellow, lemon or both with a touch of turps. See how brilliant it looks? Then mix some white with the yellow and place it beside the pure color. See how dull and heavy it looks? So you use your white primed canvas to lighten the brights the same way that watercolorists do and let the light come through.

Now as you know, you keep your canvas *as soft as you can, as neutral as you can, for as long as you can*—except for brights. So instead of establishing your trusty neutrals, then adding the color, you go the other way around, establishing an area of pure color that is larger than the area required and carefully bringing the darks in so as not to dirty those bright colors. If you get your brights dirty and then use thick opaque color to cover the dirt, not only will the flowers drop dead on the canvas, but you will be tempted to purchase some jazzy color that will make the painting gaudy. The only color that I do add to my palette for richness is cadmium orange.

Don't forget: If anything goes wrong, fix it. Rubbing out is not only allowed, but works beautifully in this situation. In fact, if something is looking dirty, rub it right back to the white canvas and begin again.

**Step 1.** *First marks on the canvas. Pure color, no white. The bright area is larger than required and the paint thin.*

**Step 2.** *Bringing the darks in warily, keeping it fluffy, and no definite decisions made.*

**Step 3.** *Adjusting and readjusting and a few more landmarks being laid.*

**Step 4.** *Now adding oil to the turps and establishing the darkest darks and the lightest lights. I have managed to keep as many areas of pure color as possible and I am avoiding the temptation to plonk in a pile of dots — of which wattle consists — by keeping my eyes tightly squinted. I don't want to see any distracting details until I have to. The feathery leaves that belong to this variety of wattle are coming along at the same rate as the blooms.*

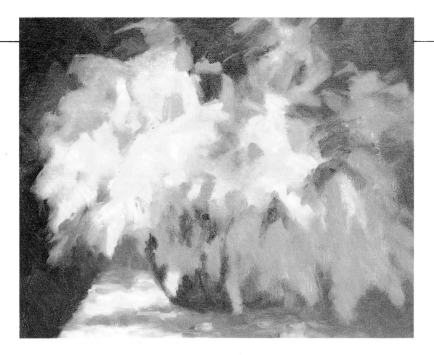

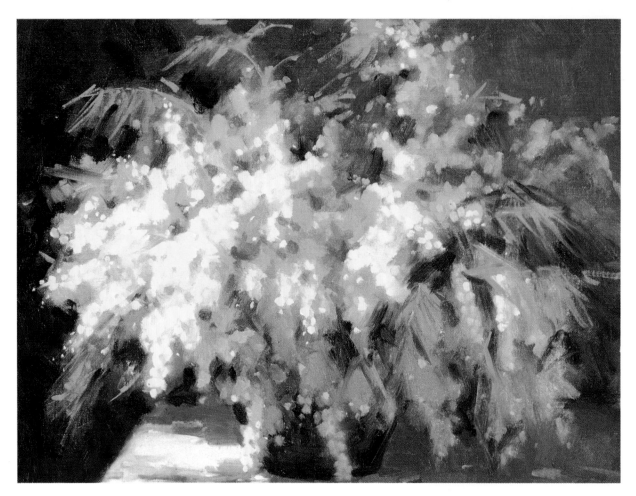

**Golden Wattle**

*20" × 16" (51 × 41 cm)*
**Step 5.** *Now you can place some little opaque dots over the darks. You need only a few to explain the subject — at least to an Australian.*

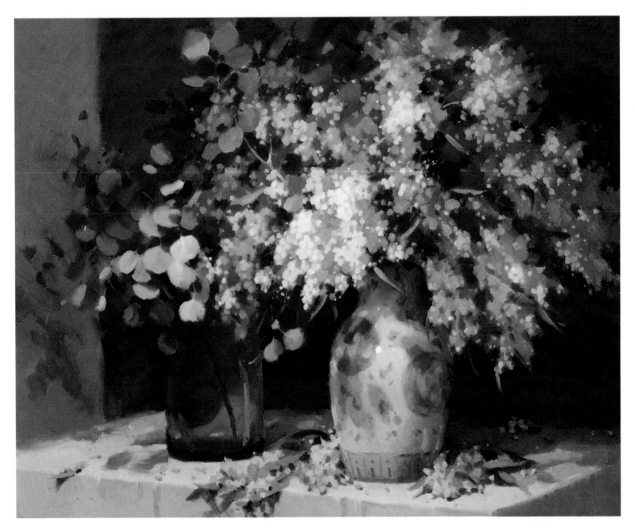

### Wattle and Blue Gums

*44" × 36" (112 × 91 cm)*
*Here is another painting I did of wattle.*
*Again, notice that though there are some*
*dots, the idea of dots is mostly suggested*
*by the accurate placement of lights and*
*darks.*

**Detail.** *Wattle.*

Some Australian flowering gums. Squint at
these and see the problem of keeping
these uncomplicated.

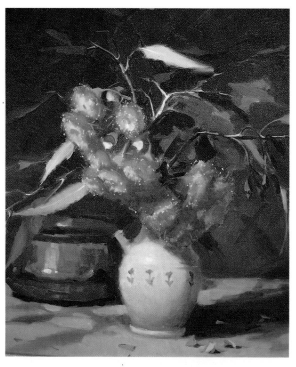

**Winter Flowering Gums**

*12″ × 16″ (31 × 41 cm)*
*Excessive use of dots would have given
the wrong impression of these flowers. On
the tree they have the appearance of fluffy
ballerinas, so that it is not hard to imagine
the ''gumnut fairies'' in the children's
books. I have laid broad soft areas and
added some dots with a no. 2 sable; the
eye does the rest.*

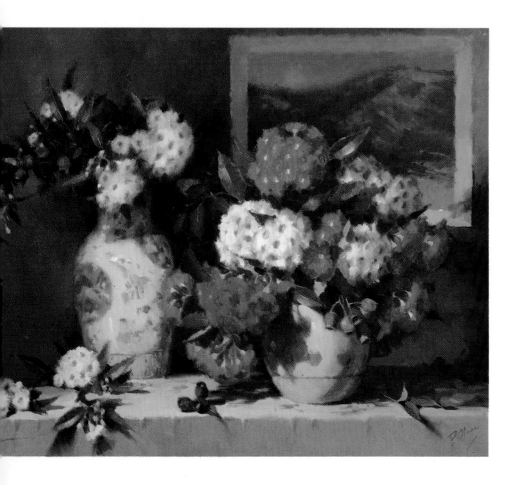

**Summer Gums**

*36″ × 30″ (76 × 91 cm)*
*Instead of pure yellow as in the wattle, here
pure reds alizarin crimson and cadmium
red were laid down first without adding
white, thus allowing the white canvas to
lighten the color.*

**Detail.** *Gumnuts. As with most flowers, particularly ones that have an oddness about them, I try to show a profile, some half in bloom, and in this case, after blooming. It would be hard to dismiss these gumnuts; the tree is loaded with these after the blooming, and they are as much loved as the flowers.*

**Detail.** *The flowers on the table. A good example of how to keep the edges soft and of painting against the form. The leaves are very obviously painted sideways except for one center mark that goes with the form and is painted with a no. 2 sable.*

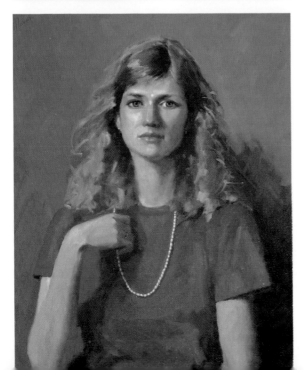

**Mrs. Eva Smales**

*24″ × 30″ (61 × 76 cm)*
*The red top was handled the same way as was the wattle. The pure color was laid down first and the other tones brought in, keeping the red clean and bright and the thin layer of paint glowing.*

# *Reflective and transparent objects*

## *Demonstration*

There are no set rules for painting reflective or transparent objects except to keep squinting and looking. Anything reflective or transparent collects what is around it, as these examples show.

The pictures on page 98 show, in sequence, the completion of the glass vase area that is seen in the full still life demonstration on pages 99-103. It is interesting to isolate this area and show that it received no more special attention than anything else on the larger canvas.

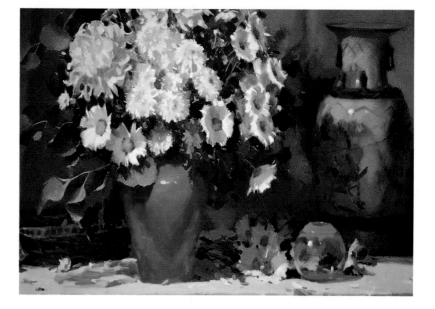

**Detail.** *From painting on page 113. Every time you paint there is a new set of* problems to solve. *This little glass vase with its opaque pinky/red top would have been painted in a completely different way in a different setting. Transparent objects take on the tones of their surroundings and therefore look different each time you paint them.*

**Detail.** *From painting on page 72. Same vase with a completely different set of tonal values. Glass seems so hard to paint because there is often a very complicated pattern of light and dark, some of which is on the surface as reflected light, and some of which is around and behind the object, visible because of the transparency of glass. The only answer is to simplify by squinting until only the most important tones can be seen, and then paint what you see, not what you know.*

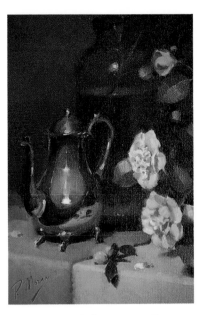

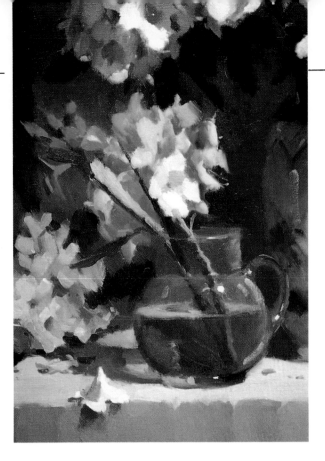

**Detail.** *From painting on page 69. Reflective objects "collect" their surroundings by reflecting them. This silver coffee pot has collected its surroundings to such an extent that, if you half close your eyes, you can't tell where it starts and where it finishes. If you tried to define the silver pot better, with harder edges or a more "silvery" color, you would actually be losing the likeness rather than getting closer.*

**Detail.** *From painting on page 79. This glass jug looks completely different from the way it looked with the tulips and ranunculi on page 83 because of the different setting. You wouldn't know it was the same jug. You're not painting jugs, you're painting tonal patterns.*

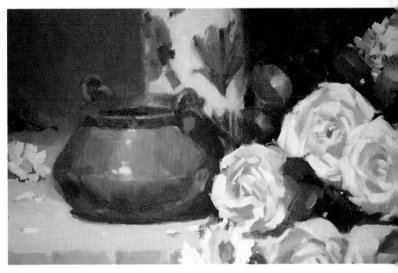

**Detail.** *From painting on page 76. In contrast, this copper teapot has aged beautifully, and it isn't highly polished, so it isn't picking up a lot of its surroundings.*

**Detail.** *From painting on page 80. This polished copper pot is picking up some of the yellow rose color. Remember that reflected light is not as bright as direct light. It's like moonlight compared to sunlight. Be sure the reflections belong to the object and don't just sit on it.*

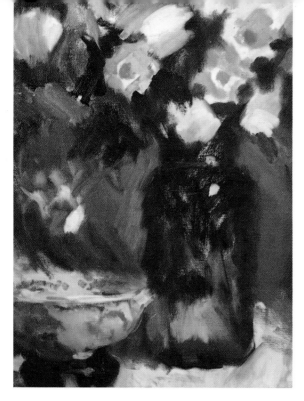

The soft nondecisive tones have been placed.

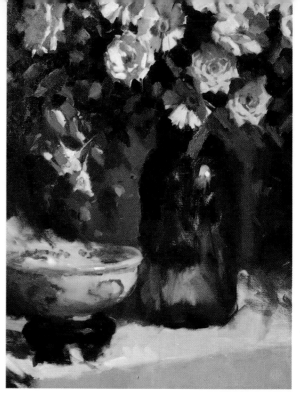

Using oil medium and establishing the darkest darks. The flowers are one step ahead of the vase. Notice that the glass vase and the bowl are progressing at the same rate.

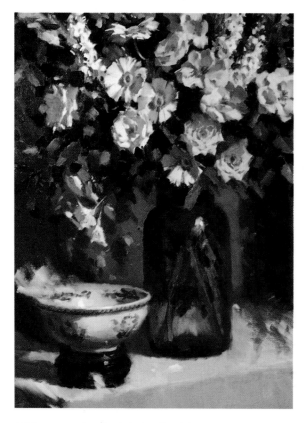

A little more work on both the bowl and the vase, more measurement, reassessment and adjusting. That is, more rubbing out and putting in again! I have great trouble with my ellipses.

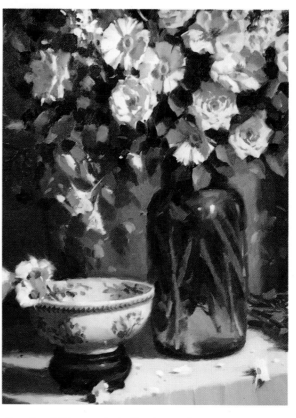

Completed. If the vase looks like glass and the bowl looks like china, it is not because that was what I aimed for; it is because I painted what I observed to be there — tone, edges and proportion.

# A large floral still life

*First marks on the canvas. This is a large canvas, 44 × 48 inches (112 × 122 cm). Before you do anything, make sure you set out big dobs of paint — there's a lot of canvas to cover in a short time.*

*The first marks here took careful consideration. Through my viewer I noted a couple of areas to use as my anchor marks. I hope they will be in exactly the same place when the painting is completed.*

### Demonstration

There is only one difference between a small floral painting and a large one — maintaining the standard of work over a bigger area, in the same amount of time as it takes to do a small painting — the *lifetime* of the flowers.

As the philosophy of this book is *painting the truth*, it is the large floral which will test the artist's limits. To me, the truth means, you do not work from photographs, you do not work from plastic flowers, and you *never* alter a flower arrangement while the painting is in progress. The eye can divide more colors and tones than the printed photograph ever could and the natural flower radiates more subtle nuances than any plastic facsimile. Also, the natural flower arrangement settles, nestles and throws shadows and reflected lights that all *relate* to each other.

A large oil painting takes many many hours to complete, and can lose the freshness and spontaneity of a small one. This is why the small "plein air" landscape sketches by John Constable (English 1776-1837) are now considered more interesting than the large gallery artworks that were worked up in the studio from these initial sketches. Fresh, easy, painted with care and love are qualities that will survive the test of time.

So, as *it is not what you paint but how you paint* that counts, it's the "how" that is the hardest thing to maintain with a large floral painting. You just have to keep at it, and, as it is in any field of endeavor, working too long without a break can produce misjudgments.

Select flowers that have a good lifespan; chrysanthemums are good ones. Gerberas survive and have a wide range of colors, but they do tend to follow the light, and a moving target is a temper tester.

As I tend to paint life-size, a larger canvas just means more flowers and more objects, but whether the size is four inches by five inches or four feet by five feet — the approach is exactly the same. Observation of tone/color, edges — lost and found, and proportion in order of appearance. A large painting is a major commitment, but can be a very exciting prospect.

Get that blank canvas covered as fast as you can. *You cannot make any proper judgments until you have something to judge. All the shapes, tonal values/colors and edges are relative to each other.*

*Squint those eyes and establish big, broad masses. Make a simple statement out of what you see — nothing definite, everything moveable, and check those anchor marks.*

*I open my eyes a little more and work across the whole canvas, working back from the light areas. Remembering the black and white scale and how the center tone looked different in different surroundings, so the canvas has to be looked at as a whole. I make every decision from the standpoint, using the viewer with my eyes squinted and checking that those anchor marks haven't drifted off their spot.*

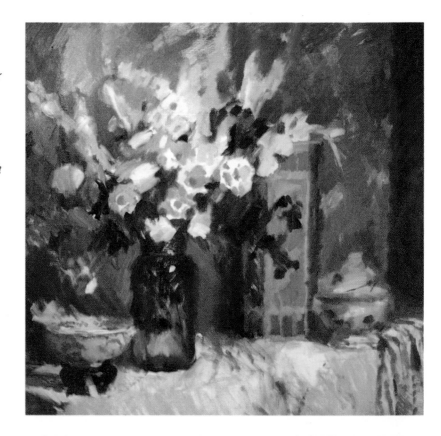

*When do I get into oil? When everything is in the right position. I don't want to have to alter or rethink anything, because this is the time I've been waiting for, the time to just paint. Add stand oil to the turpentine (the balance should suit yourself and the conditions), and the very first thing to do is to place the darkest darks and the lightest lights. See how this alone lifts the whole painting. Now everything is established — position and tonal range — it's time for the midtones to be matched in between. The main rose is beginning to emerge naturally as the point of interest, since it is the area where the darkest darks sit next to the largest area of light. Note how the glass vase from the previous demonstration is coming along at the same rate as the rest of the painting. Now this is usually where the next question arises, Where do I go from here?*

*So where do I go from here? Back to the point of interest — the arrangement of flowers. Do a bit of work there, and then go across the rest of the canvas to bring it up at the same rate.*

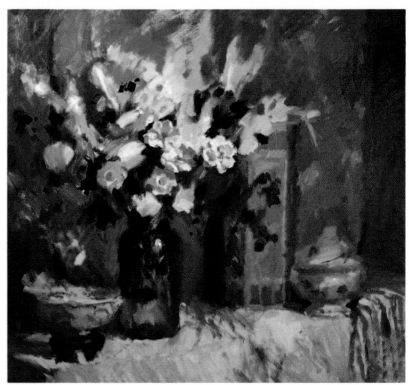

As there is enough information established—the full tonal range is well in position and a couple of firm anchor marks—I have to get moving on those flowers before they fade and droop. Faded and fallen flowers alter the tone/color relationship of the whole canvas, and their demise is being accelerated by the use of the spotlight.

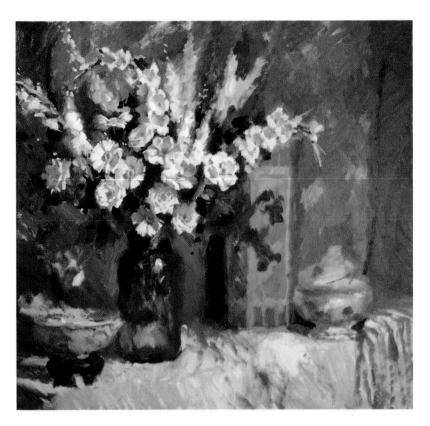

Incorporating more work on the background into the nearly completed flowers. More work has continued across the whole canvas, except for the striped material, which was established early in the painting and hasn't been touched since. That soft neutral area on the table is waiting for the last lot of replacement flowers that are sitting in a nice, cool spot waiting their turn. I really worry about putting them through such rough treatment, but I console myself with the thought that if the painting works, they will really be lasting much longer than if they had stayed on the bush.

I don't mind saying I had to really concentrate to finish this painting. It took days of thinking and working, and the temptation to go shopping was very strong.

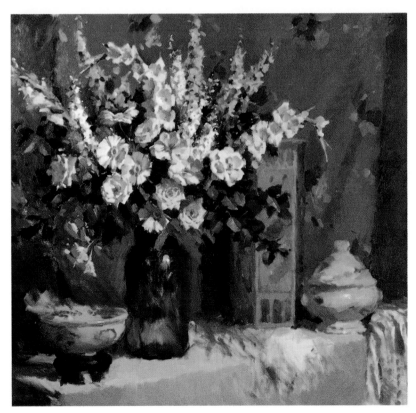

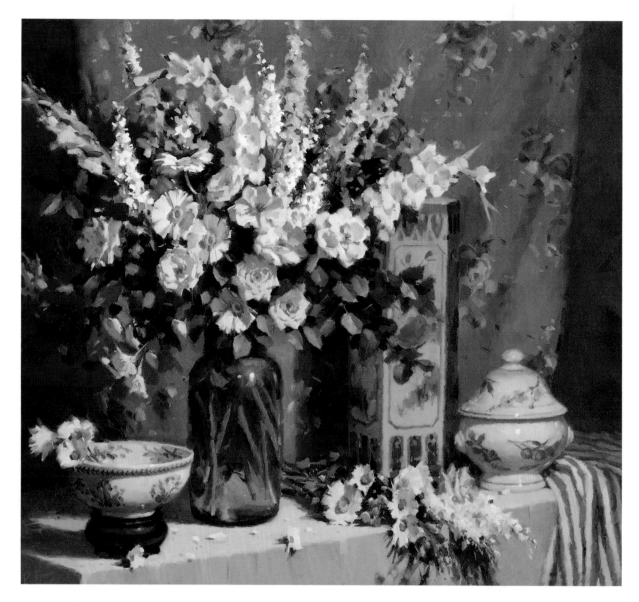

When these flowers don't need to be painted anymore, I can slightly disturb the arrangement and put in one or two fresh flowers to maintain the tonal range. As the blooms fade they alter the original tone/color relationship of the painting.

I established the darks and lights while keeping my eye on the point of interest. Paint the hands while looking at the face *applies here. Care has to be taken that the painting is brought to a satisfactory conclusion without taking your eye off the ball. Ask yourself* what is attracting too much attention, and what is not attracting enough attention, *and* relate every brushstroke to the whole canvas.

**Detail.** *Main flowers. As you can see, there's very little paint. It's better to see the flowers than the paintwork.*

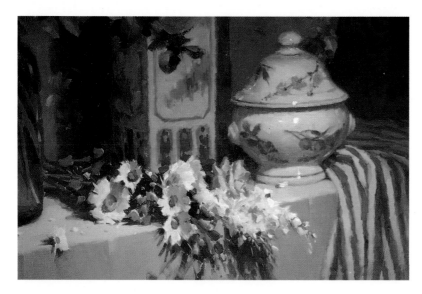

**Detail.** *Flowers on the table and the tureen. If these flowers hadn't been replaced towards the end of the painting, they wouldn't have looked like this. Dead flowers doth not a cheerful painting make.*

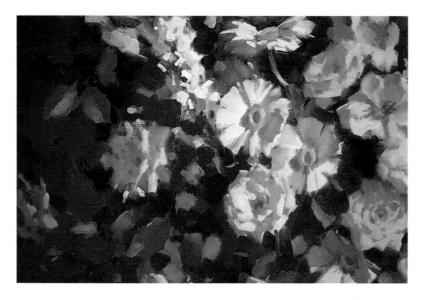

*How can you cut a rose in half and get away with it? Easy. Place it in a secondary area, and the other half won't be missed.*

## Chapter twelve

# *Tips for landscapes and portraits*

*Demonstration*

The following pictures demonstrate that I arrive at the end product (a finished painting) in the same way, whether it be a landscape, portrait or still life. As you can see, it doesn't matter what you are painting; it is always another *set of problems to be solved* in order of appearance — tone, edges and proportion.

**First marks on the canvas**

*Establishing a simple statement, masses not broken up*

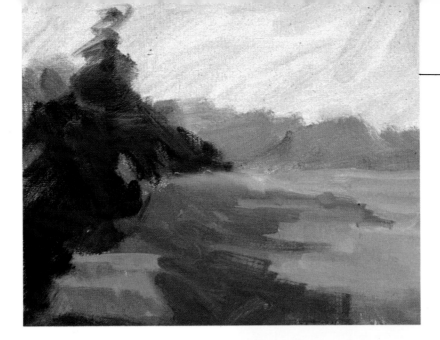

*Establishing the darkest darks and lightest lights, then the mid-tones*

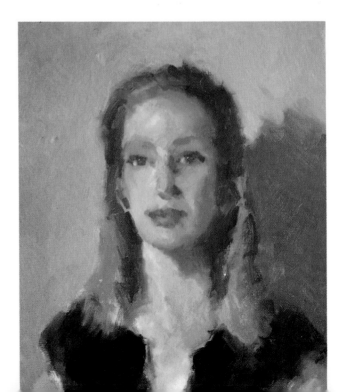

*Finished paintings*

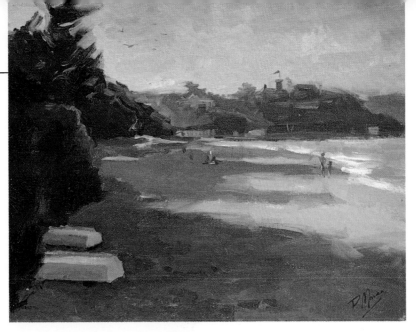

**Last Sunlight
Sorrento, Victoria**

*14" × 12" (36 × 31 cm)*

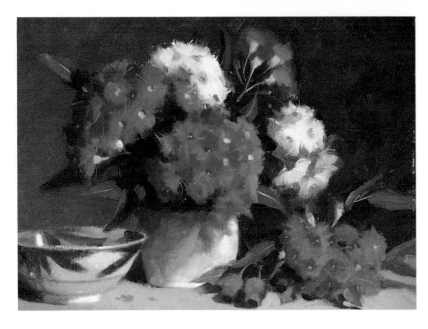

**Bright Gums**

*16" × 12" (41 × 31 cm)*

**Red Earrings**

*16" × 20" (41 × 51 cm)*

# Part V

# Finishing

# *Those finishing touches*

*16" × 12" (41 × 31 cm)*
*A certain amount of control is needed for a subject like this. These last marks painted with the form are much more prevalent here than in most paintings. It's one of my "stalkier" ones. You do need a steady hand. If you don't have one, either choose another subject, practice to get that hand steadier, or rub out a lot. I have done quite a bit here of what I call "painting in and painting out." Some of the leaves and stalks have been painted in softly against the form, and the dark areas next to them have been painted with the form.*

Are you too scared to put on those final little brushstrokes — including the signature — because they may pull your painting down? (*A painting is only as good as its worst point*, after all.)

Many of the beautiful native Australian plants show their stalks. To avoid putting in those shaky, amateurish sable strokes, I used to leave stalks out. I had stalkless flowers. Simple. It was better than putting in bad ones, but not likely to change the course of art history. I tried every trick in the book. Sometimes I leaned a long brush across the canvas and leaned my shaking hand on it, or I'd wait until the painting was dry so I could rub it out if it didn't work, but by then the flowers were dead and I couldn't see what to paint anyhow.

There was an artist who had a car accident and lost the use of his right hand. He was told to develop his left hand by taking a pencil and with big sheets of paper just spending hours trying to draw straight lines. He now paints with his left hand. So I tried this with my right hand. The control began to appear almost immediately. I was so excited by this breakthrough that I painted everything with stalks, the stalkier the better. Of course, as with all development there's that pendulum swing: too soft, too hard; too light, too dark; too dull, too bright; too unfinished, too finished — overkill. I now try to keep my finishing touches in perspective.

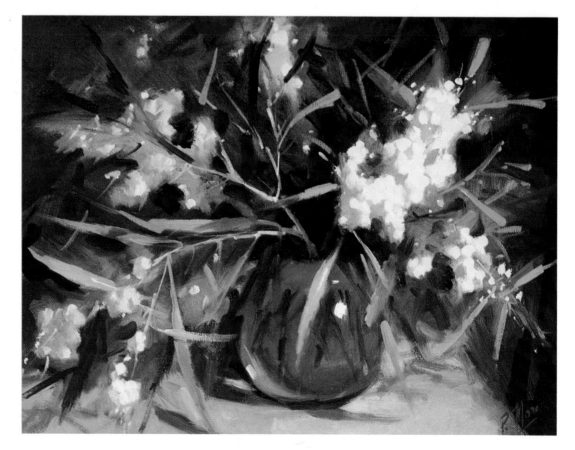

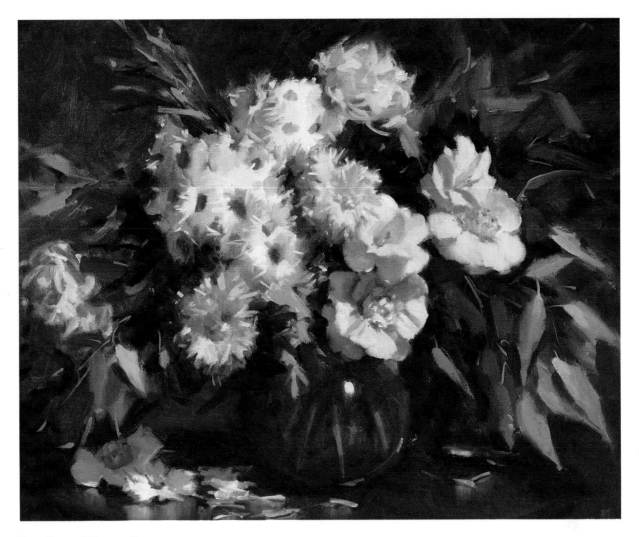

**Camellias and Chrysanthemums**

*24″ × 20″ (61 × 51 cm)*
*This one is less "stalky," but the chrysanthemums needed quite a lot of marks with the form. They were put in last over a very soft area with a no. 3 sable.*

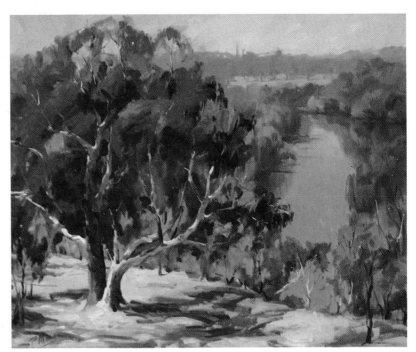

**Yarra at Studley Park**

*30″ × 24″ (76 × 61 cm)*
*This was a "stalky" landscape. You can see how the softness is brought immediately into focus with just a few marks.*

# The signature

Here it is, the grand finale. The painting is finished and you are happy with it—hooray! Stop! Before you sign that painting, remember: *A painting is only as good as its worst point.* Is your signature going to spoil that masterpiece? Have a look at it. Have you always felt happy about your signature? Do you carefully select the area to place it or do you always put it in the regular place whether it suits the painting or not?

*The Signature Is
Part of the Painting.*
Have you ever noticed how many well-painted pictures have a nervous signature that doesn't seem to belong to the painting? The immediate impression is that a nonprofessional has painted it. My teacher was horrified by my signature on my paintings. Every letter was pedantically printed and placed methodically along the bottom, regardless of whether it destroyed the balance of the painting or not. He had seen my handwriting and signature many times (on checks, no doubt), and it was the complete opposite—large and whizzy. He claimed it was dramatic, and probably the worst writing he'd ever seen. Why didn't I sign my paintings like that? I had never thought about it before but I set about practicing my signature like handwriting (same as the stalks). It certainly felt more like me. I did it until my arm nearly fell off, and people seem surprised when I tell them that I still rarely get my signature right the first time. As with the rest of the painting, I go to great pains to make it look like it was painted with ease. If you have to work, don't look it!

Again, *big brush, big area; small brush, small area.* Don't use a broom or anything inflexible. I use a size 2 or 3 round sable. Paint is not like a pen with endless ink—a couple of strokes and the brush is empty. I mix the paint to an easy consistency and may have to dip into it after every stroke. Like the rest of the painting it has to look like it has been painted with ease even

**How to sign: trial and error.**
*1. Dip into the paint like you are dipping into ink, only the paint won't go as far, most times just a letter or half a letter. So I made it through the first letter without blobbing or sailing off course.*
*2. Made it through the P but the M isn't any good.*
*3. After each letter, stop and dip into the paint.*
*4. Stopped again, ready for a refill.*
*5. Made it through the signature, but look at the underlining! Start again.*

though you have just ground the points off your teeth. My signature includes underlining and this is often my undoing. Many times I have done the first part right, and the underlining stroke goes the wrong way, or blobs, or I get heavy handed and you can see it from forty paces. Start again. On a good day it will be right the first time; on a bad day I give up and come back next week.

## What Color Can You Use?
Any color you like. I often use a dullish red.

## Where Do You Put It?
An artist friend of mine delights in the fact that no one can find his signature. I prefer people to be able to read it. It may match the spiky grass in a landscape, light up a negative area, or blend into the shadows. It can be top or bottom, just as long as you have thought carefully about it and placed it where you feel comfortable, and as long as you get the feeling that the person who signed the painting was the person who painted it.

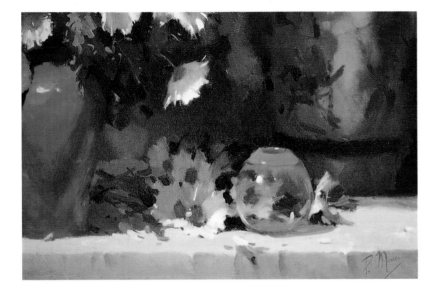

**Detail.** *This signature was placed at the bottom right.*

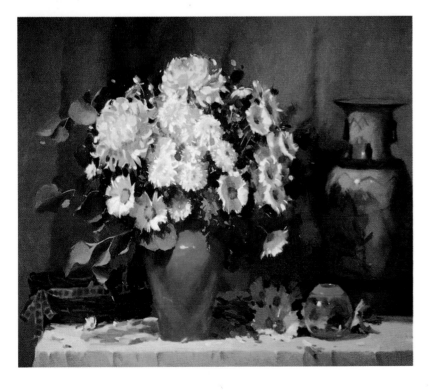

**Red and White**

*36″ × 30″ (91 × 76 cm)*
*A signature at the top would have been acceptable, but I felt it rounded the corner off nicely here.*

**Detail.** *Signature on bottom left.*

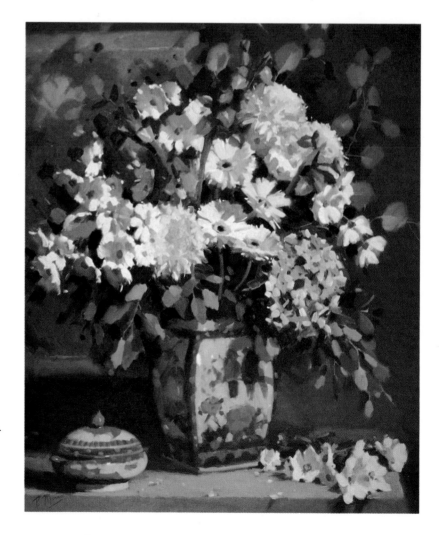

**Gerberas in Bluebird Vase**

*30" × 36" (76 × 91 cm)*
*A top right-hand signature would have dragged the eye too far to the right; top left and bottom right would have interrupted some interesting areas.*

Bottom right-hand signature here. The bright red here could have dominated the painting if it didn't fit in.

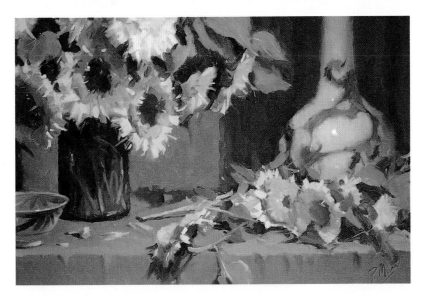

Here you can see in the extended area that the red signature is an extension of the reds running through the painting.

Top right-hand signature here.

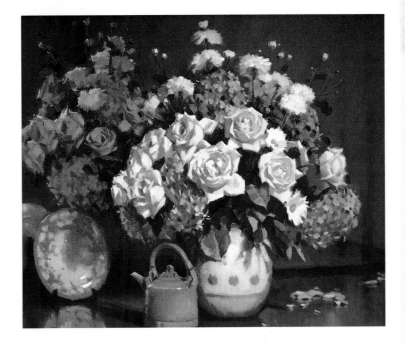

**Reflected Roses**

*36" × 30" (91 × 76 cm)*
*That top corner needed a little something; it was looking a bit empty.*

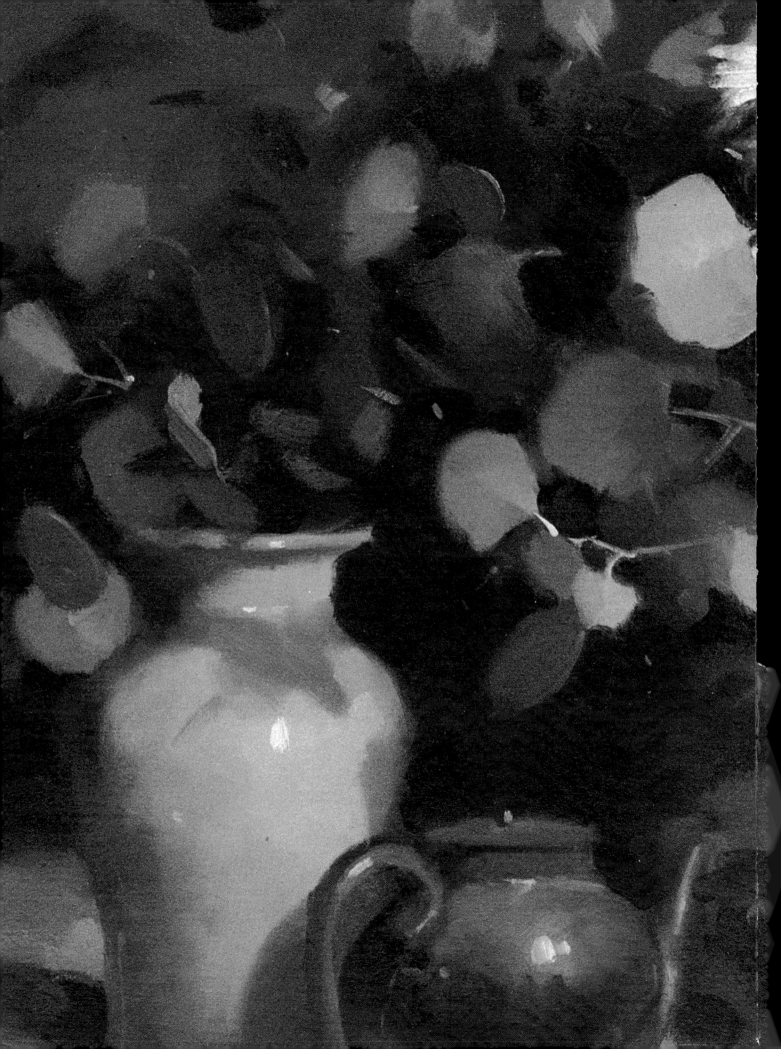

# Part VI

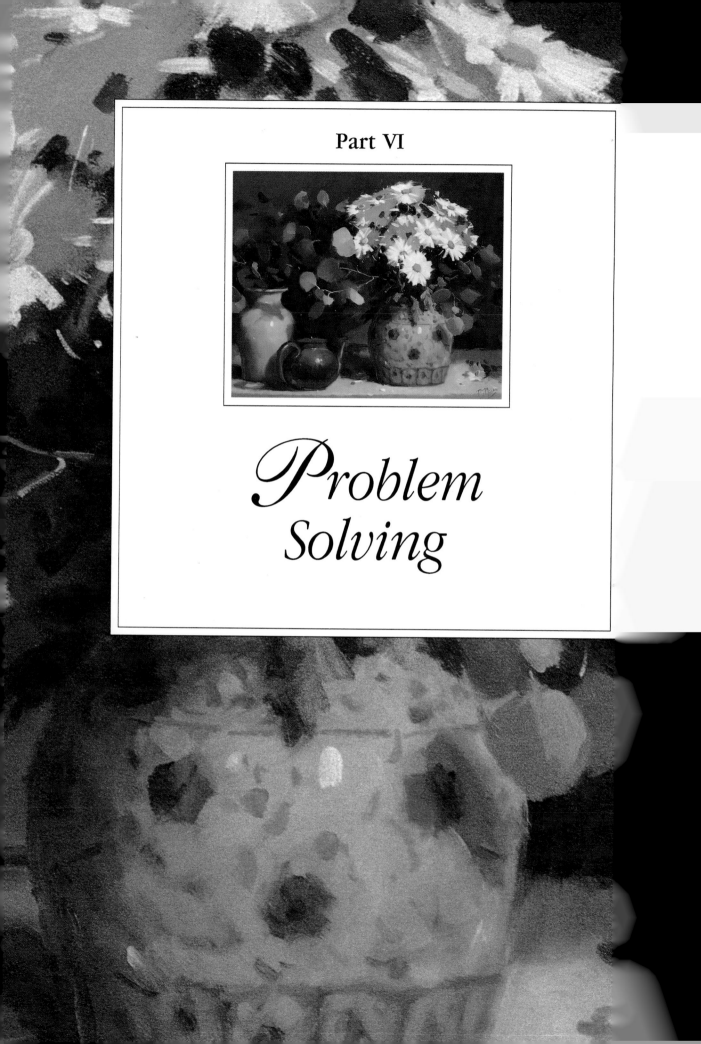

# *Problem Solving*

# Five of the most asked questions

## 1. Why Doesn't It Look Right?

Ninety-nine percent of the time, the reason why it doesn't look right can be traced to one or all of these three things: midtones, measurement, and/ or observation.

### Midtones

Midtones are the hardest thing to conquer. Anyone can get the lightest tone (white) or the darkest tone (black), but it takes quite a while to learn to evaluate and relate the ones in the middle. Midtones tend to produce optical illusions when they land next to a tone that makes them appear lighter

or darker than they really are. For instance, on a scale of one to nine, it is easy to see the tones getting darker down the scale, but if you have a look at the chart on page 19, the middle tone looks light against the dark and dark against the light. As a subject scrambles these tones all over the place you must look at the *whole* canvas as one tonal scale. Half close your eyes and work back from your lightest light. Nothing will look light unless there is a dark next to it. *Everything is relative.*

Most students tend to make the midtones too light. I used to get the whole key of my paintings too light and the darkest darks looked so sudden and attracted so much attention that I then lightened them and finished up with a big, pale, insipid nothing. You must *really* screw up those eyes and work back from the lightest light. A good test is to paint something white, white flowers in a white vase, for example. If the vase has a highlight, then the vase has to be darker than the highlight, or the highlight won't show up. The shadow side of a white flower or a white vase can be a lot further down the tonal scale than you think. In most cases, *the dark side of a light object can be darker than a dark object in the light.*

Generally, the smallest areas of a painting are the darkest darks and the lightest lights. The largest area is made up of those all important midtones.

### Measurement

Have you measured *everything*? Every tiny bend in the petal or eyelid, every direction and how-many-times-into? Sideways, crossways, and up and down? There is only one difference between a plain girl and an attractive

**Porcelain and Daisies**

*36" × 30" (91 × 76 cm)*
*This is a good subject to trick the peepers.*
*If you peep at the subject from your canvas, the subject changes completely. The reflection goes somewhere else and alters the counterchange of tonal values. Make all decisions from your standpoint.*

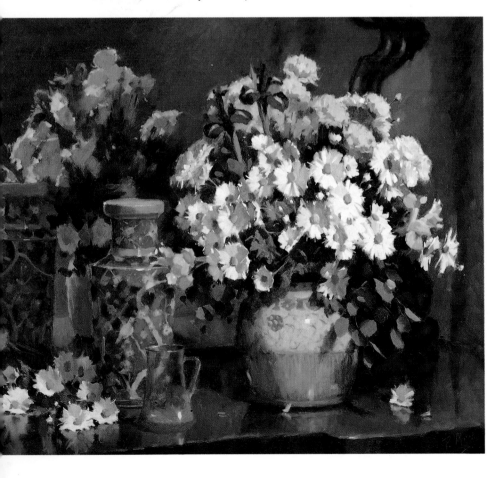

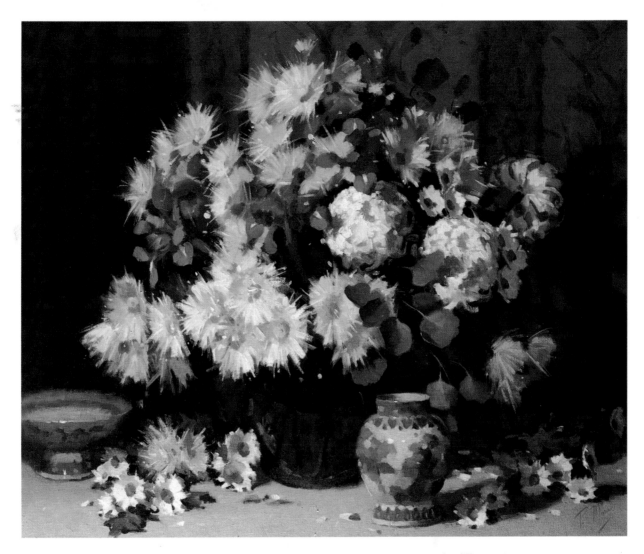

one—effort. It works with painting, too.

If you have done everything right—checked the tones with your eyes squinted, measured and looked at it backwards and upside down—and it still doesn't look right, well, just keep at it; you're on the right road. Practice and experience will iron out a lot of those deficiencies, and after spending an age just sitting on a plateau, you can have a blinding flash and reach a major breakthrough. Enthusiasm often makes up for lack of talent, and that applies to any field of endeavor. If you have both, you are doubly blessed.

## Observation

There is a good chance you have been painting what you *know* to be there—a vase, a flower, a tree—and have not been squinting your eyes and objectively *observing* what is there. When you observe the patches of light and dark you are establishing shapes that often have no relation to the known boundaries. By just working on the known boundaries without squinting and taking the subject in as a whole unit, you run the risk that your painting will become a stiff, glued together menage that is really just an enumeration of objects.

### Cool Tones

*38″ × 32″ (96 × 81 cm)*
*There are a variety of white flowers here and the big chrysanthemums are the whitest. Half close your eyes and see how dark the dark sides of these big chrysanthemums are. Very dark, yet it still looks right, and still looks like the dark side of a white flower. Have a look at the blue and white ginger jar. Squint your eyes and look at the dark side. It is probably much darker than you would think a white vase would be, and yet it still looks right. Even the light table cover is many tones darker than the white daisy chrysanthemums lying on it; otherwise they wouldn't look so white. Keep working on those midtones.*

## 2. Where Do I Go From Here?

This is usually the question asked when the block-in has been thoroughly established and all the basic problems have been solved—correctly. Somehow at this stage most students get a mental block and a bit of direction is needed. This is where you begin again. Have a look at these examples.

Keep in mind that the whole canvas has to be kept at the same level of completion, but at each stage you have to begin again somewhere. Assuming you ascertained right from the start what your initial impression was or your point of interest, I would suggest you go to that area and begin again.

What you now do is a painting within a painting. Start on that small area and ask yourself all the same questions that you did when you began the whole new canvas. That is, still observing and making all decisions from your standpoint with your eyes squinted, establish the simple broad areas of tone first in that small area. Then break up those areas by asking

*This is usually the stage reached when the question arises, Where do I go from here? Here the block-in is completed and the biggest differences between the subject and the canvas have been evaluated and eliminated. Painting is a continual series of critical appraisal, the continual asking of the question "what is now the biggest difference—in tone, edges and proportion—between the subject and the canvas? This approach should take the artist through to the completion of the painting; but it is at this stage that most students get a mental block and need a bit of direction.*

*Go back to your point of interest and begin again.*

yourself, "What is the biggest difference—in tone, edges and proportion—between the subject 'just in that small area' and the canvas."

However, do not make one mark in that small area without going back to the standpoint and considering how it relates to the whole canvas. In other words, if you are working up a small area, and maybe placing the darkest dark of that small area, you then stand back and observe the whole canvas. What looked very dark when tunneling in on that spot may not be the darkest dark when relating it to the whole subject. *Everything is relative.*

As you begin to break down the broader masses of tone, there is a good chance you will need smaller brushes—*big brush, big area; small brush, small area*. Don't try using a no. 12 broom if you are breaking up stamens.

So, as you have now taken the point of interest a step further, bring the rest of the whole canvas up to the same stage of completion. Remember that, while not every section of the painting has to be worked up, even those lost, loose areas do have to explain themselves.

After you have brought the rest of the canvas up to the same level of completion, then return to the small area and continue asking, "What is now the biggest difference in tone, edges and proportion between the subject and the canvas?" (Have a look at step five of the large floral demonstration.) So, these yellow flowers now have a few more areas established, and it is time to move on. *Don't work on one spot too long!*

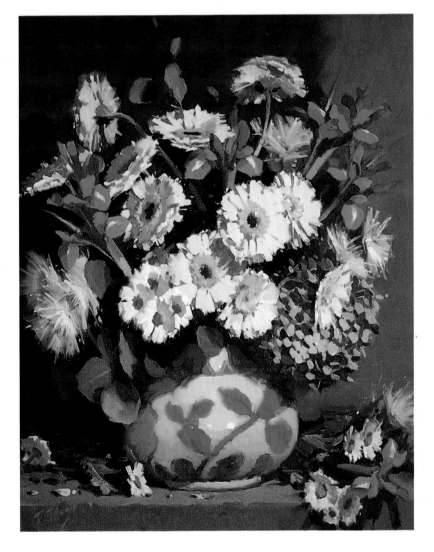

**Sunny Yellow and Blue**

*24" × 30" (61 × 76 cm)*
*As those two yellow gerberas were the main point of interest, that was the spot that I returned to when I wished to take the painting that one step further. When do you give up working over the painting? See the section on "How Do I Know When to Stop?"*

# 3. How Do I Finish a Painting?

Have you ever entered a gallery, clapped eyes on the most stunning painting, rushed over and then said, "Oh, there's nothing there close up"? Many painters believe that if you have the tone and color right, the eye will do the work and fill in the detail. However, the eye won't do the work unless there's a bit of a lead. The viewer will think his eyesight has gone and search for his glasses. A painting that has uniformly soft edges is as unsettling as a painting that has uniformly hard edges. It is like music that is continuously soft or loud; you need hills and valleys to make it interesting.

There is a natural reason for this discomfort. *The eye can only focus on one thing at a time.* Hold up your brush and look at it. Notice how the background is out of focus? Now try it the other way around; if you look at the background, your *brush* will be out of focus! Therefore, there will be areas of a painting that are more in focus than other areas. There will be soft and hard (lost and found) edges.

Turn your back to the painting, close your eyes, then whip around and have a fresh look at the painting. If your eyes go to a certain point, that will be your point of interest; that is, the area that will need a little more detail and will lead the eye to do the work on the rest of the painting. Do *not* use "selective focus" as photographers do, that is, decide what *you* wish to put in focus. There will be a *natural* point of interest.

So, to make a painting look finished you have to develop certain areas; the other less developed areas will then be explained. However, the finished areas should not be isolated from the rest of the painting. Sometimes you just need a suggestion to keep the eye doing the work. *Observe.* You will also find that with one specific area slightly more finished, your painting will probably look just as good up close and not worse. If you have stuck to the ideas *"Keep it as soft as you can, as neutral as you can, for as long as you can"* and *"big brush, big area; small brush, small area."* You may find you need only a few flicks from a sable to make that area appear finished. The more accurate you have been in the beginning

*If you hold your brush up before your eyes and look just at it, everything else appears blurred. The eye can only focus on one thing at a time.*

*Now, still holding the brush in the same position, look at what is behind it. The brush will be blurred. So it is with a painting. There can only be one developed area or the eye will become confused.*

with tone, color and dimensions, the less finishing you will have to do.

It is the balance of hard and soft (lost and found) edges, tone, color and proportion that will give a picture believability. How wonderful to be able to put down your own poetic dreams exactly the way you wanted to and have them remain like that forever.

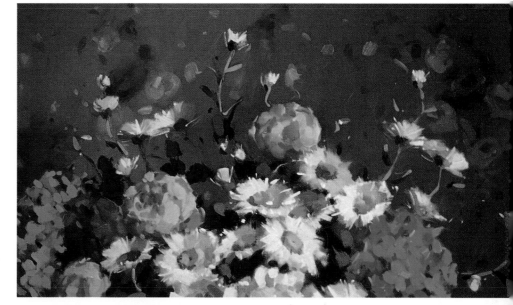

**▼ Dahlias and Hydrangeas**

*30″ × 24″ (76 × 61 cm)*
*On each of these hydrangea heads there is one floret painted in focus, and that's the lead your eye needs for the brain to complete the explanation. If you don't have a lead somewhere, your eyes will feel they need glasses, or if there is too much detail, your brain will register confusion.*

**▲ Detail.** *Here is the principle demonstrated in oil. The daisy buds are in focus and the background is out of focus. It is not only the lost and found edges that make this appear so, but the daisies contain the full tonal range, from darkest dark to lightest light, whereas the background has a reduced tonal range, reduced color and lost edges. What has been painted is what was observed to be there, in order of appearance.*

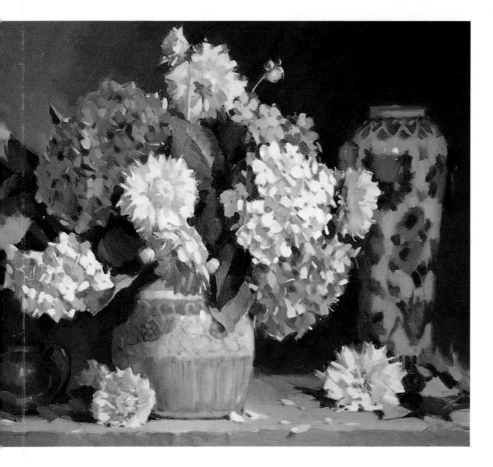

# 4. How Do I Know When to Stop?

It is said that you've finished a painting when you've had enough. To force a completion would be to overwork it. You could ruin a fresh, spontaneous picture with a nonspontaneous finish. However, these are some questions to ask yourself:

**1.** *What was your initial impression and is it still there?*

**2.** *Are there any areas that don't explain themselves?*
Does that tree look like a frog; do those chrysanthemums look like hydrangeas?

**3.** *Are there any areas that are attracting too much attention?*
Do you keep looking at that dark shadow instead of the object? Is the vase more finished than the flowers when you meant it to be the other way around?

**4.** *Are there any areas that are not attracting enough attention?*
You did a painting called "The Green Shawl," but you keep looking at the red vase.

**5.** *Are you happy with the signature?*

**6.** *Don't look for faults, or you will find them.*
By this stage you will most certainly have visual fatigue. Put the painting away for a couple of weeks, and let the gremlins work on it. You may be surprised when you look at it again. If you look hard enough at any of the great paintings, you will probably find some area that is weak—and that can really make you feel good!

*This is the type of thing you have to look for when checking over the painting, just before you call it finished. That daisy bud managed to land right in alignment with a stem in the glass vase. There is also a daisy sparkle that doesn't explain itself. It has landed near the other stem in the glass, and it looks more like a mistake than something that was meant to be there. These two marks are attracting too much attention, and even if the viewers don't consciously acknowledge these marks, they can make them feel uncomfortable without knowing why.*

*Both marks taken out and the area now looks much more settled. This is much more comfortable to look at.*

## 5. For How Much Should I Sell My Paintings?

Be realistic. Say to yourself (or an honest family member), would I pay that much? What do you look for when you buy an article? Probably value for money. The average person doesn't know that you spent a fortnight on tranquilizers to complete the painting, just like you don't know that someone put three sewing machine needles through their finger making that jacket you're trying on. Just because it was hard work doesn't make it good; nor is it good because you breezed through it either. Even if your friend who can't paint for nuts gets a million for each painting, that doesn't mean you have to follow the market price. Just because your rent went up or the only frame that suited the painting cost a bomb, you don't double the price. *You know* when you've done a good painting, and when you start selling, you'll get a feel for pricing your work.

You may spend the early part of your career (as do a lot of people who begin their own businesses) practically giving paintings away. Then, as you improve and begin to sell, you creep the price up. If they're still selling, let the price creep up again. If they stop, you stop. If your paintings are selling like hot cakes, don't let it go to your head until you've established your selling rate. Then you can go for it. This can be a dicey business, so always leave a track back. Forget your ego.

I have noticed that the people who buy my paintings are not necessarily rich people (they didn't get rich by spending) but people who genuinely love paintings. They probably forgo other things to get a painting they love, as other people would for a musical instrument, a pedigreed pet or a college education. It's a great compliment to have a stranger see the dream that you saw.

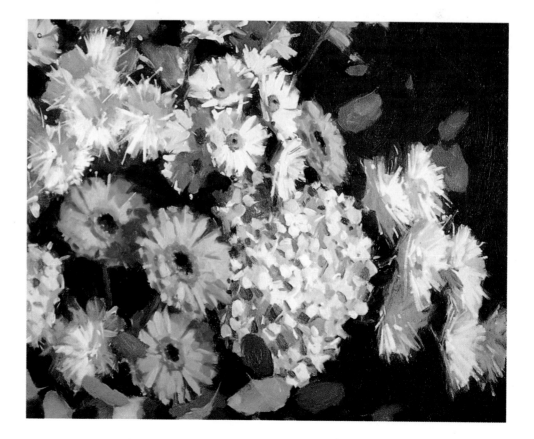

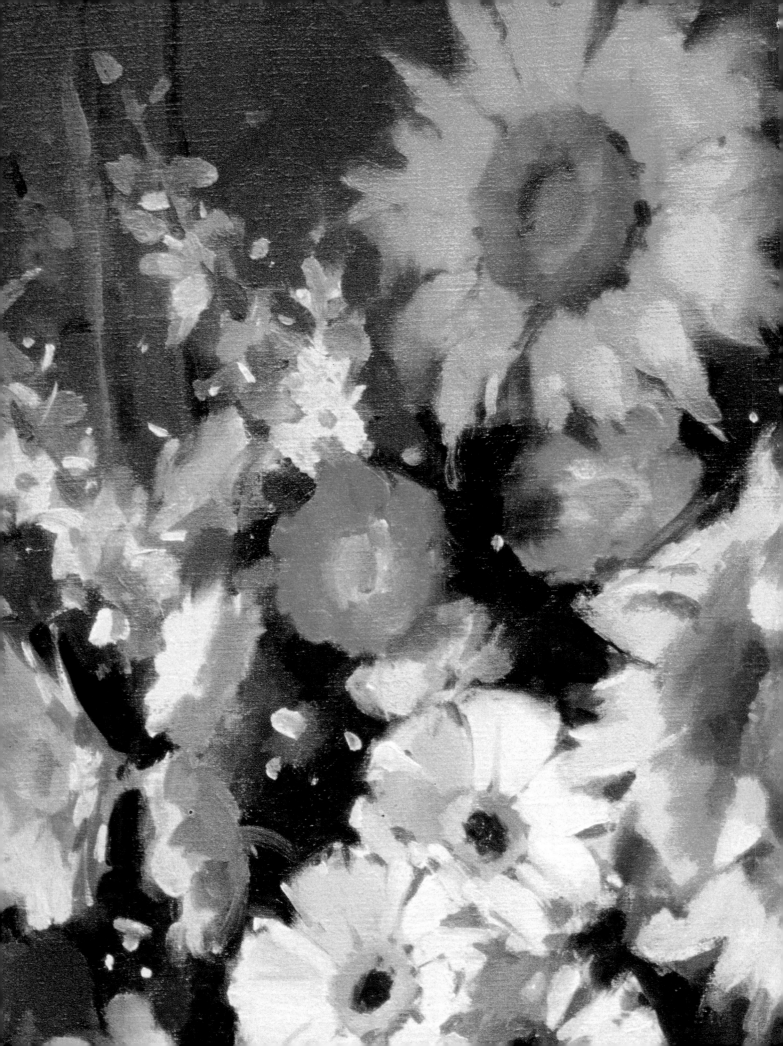

# *Key Catchphrases for Painting*

These are phrases I have used throughout the book. I hope that these short catchphrases will help bring to mind some of the bigger ideas I have tried to teach.

It is not what you paint but how you paint it.

Paint what you love and love what you paint.

Maintain that initial impression.

Relate every brushstroke to the whole painting.

The spaces can be as interesting as the object.

The shadow can explain the object.

Cover that blank canvas as fast as you can.

Near enough is never good enough.

Paint what you observe to be there, not what you know to be there.

EVERYTHING is relative.

Make a simple statement out of what you see for the block-in.

More look than put.

What you have is just a set of problems to be solved.

Do not aim for a likeness; solve the visual problems and the likeness will develop naturally.

Keep it as soft as you can, as neutral as you can, for as long as you can.

Stingy palette, skimpy painting.

Get as much done as soon as you can, as there is always so much more to do.

The more you get the groundwork right, the less finishing you will have to do.

If you are mixing a light tone, dip into the white first; if you are mixing a dark tone, dip into the darks first.

While you have a brush in your hand, see where else you can use it—economy of effort.

Reflected light is like moonlight compared to sunlight.

The dark side of a light object can be darker than the light side of a dark object.

Big brush, big area; small brush, small area.

Paint the hands while looking at the face.

A painting is only as good as its worst point.

Is it attracting too much attention or not enough attention?

Don't count on happy accidents.

Don't work on one spot too long.

The eye can only focus on one thing at a time.

The signature is part of the painting.

# Finally

These guidelines for painting—the combination of color and chiaroscuro—have been used by painters such as Rembrandt, Vermeer, Constable, Velasquez, Chardin, Manet and John Singer Sargent, and no one can deny that these artists have influenced generations of painters with the integrity of their work.

I know that, without a framework to work within, I would still be stumbling around with my five tubes of paint. Even the artist who changes direction has a better chance of succeeding when he or she has a solid understanding of representational art. I am amazed and sometimes envious of the ingenuity shown by many artists in composition and choice of subject matter, and often disappointed when the paintings don't succeed because of the artist's lack of information as to *why* things appear as they are. Being a "tonal painter" doesn't mean that everything has to pop out of the dark or be all gloom and doom, but the knowledge of tonal values or chiaroscuro will help the artist observe the way any subject appears to the viewer.

I wasn't particularly keen on still life until I began to learn painting. The obligatory bunch of stationary jars and vases became more interesting under keen observation and were positively transformed under certain lights. One go and I was hooked. No one's antique porcelain or copper pots were safe from my greedy clutches. I tend to use timeless pieces in my work so the painting is not just a "fashion piece." I like to think it doesn't belong to any era, but that the balance of color and lights and darks will be viewed happily forever. I believe *it is not what you paint, but how you paint it* that counts.

So, observing the visual truths of any subject will give the artist a framework to work within—a diving board to putting those dreams on canvas forever.

# Index

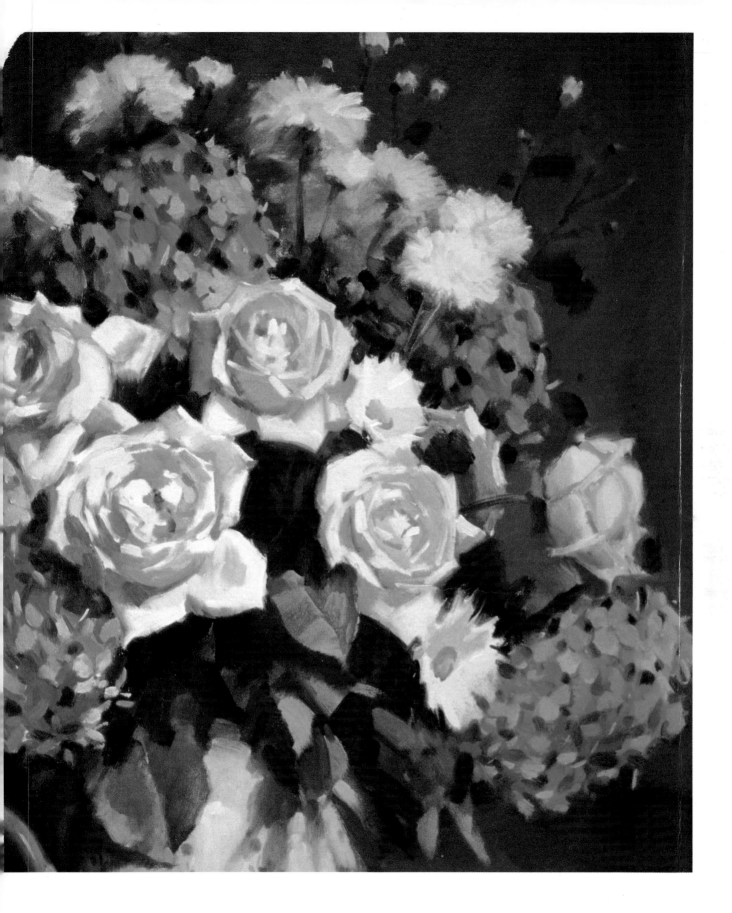